ART
MADE FROM
BOOKS

———————————

ART MADE FROM BOOKS

Altered, Sculpted,
Carved, Transformed

COMPILED BY
Laura Heyenga

PREFACE BY
Brian Dettmer

INTRODUCTION BY
Alyson Kuhn

CHRONICLE BOOKS
SAN FRANCISCO

Library of Congress Cataloging-in-Publication Data available.

ISBN: 978-1-4521-1710-2

Manufactured in China.

Design by Hillary Caudle

10 9 8 7 6 5 4 3 2 1

Chronicle Books LLC
680 Second Street
San Francisco, CA 94107

www.chroniclebooks.com

CONTENTS

PREFACE

BRIAN DETTMER

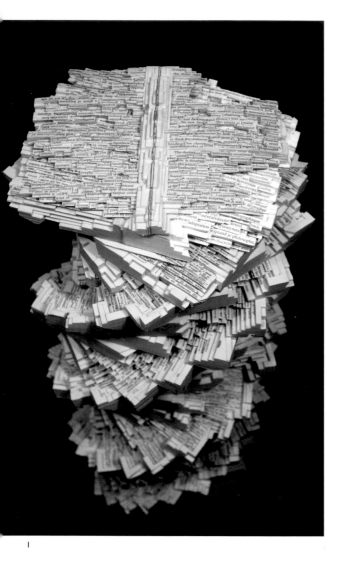

I grew up in the eighties right across the street from a school for the developmentally disabled. My brother and I loved to dumpster dive, always out of curiosity rather than necessity. The excitement of exploration was balanced with an equally strong sense of obligation to save valuable items from being thrown away. This sense wasn't merely for the sake of being environmental. It was for the sake of the object, and the potential for its resurrection, revitalization, and rebirth.

Our favorite spot was the cluster of dumpsters behind the school. There were a few times we discovered several dumpsters full of hardbound books. We couldn't believe anyone would throw the books away, and we would gather boxloads to take home to our attic library. They may have been out of date, or useless to us specifically, but we would take them for the titles, the pictures, and often for the actual stories, or sometimes just because it was a book. We had a massive attic library due to our diving.

Encyclopedias were like swimming pools to us. We didn't have our own set but we always knew someone who did. We could politely negotiate a quick swim into the neighbor's set or, if we needed a longer swim, we could walk to the library downtown. At the library we could get refreshed and gather interesting ideas from deep within the waves.

The situation has changed.

The book is no longer the king of the information ecosystem. We can now access almost anything instantly online, and bound encyclopedias have become large land mammals that can't compete with the newer species. They have collapsed and they can't go on. Do we feed from the carcass? Ideas, like protein, are valuable and shouldn't go to waste. They should be consumed by someone. Or, do we treat them through taxidermy to preserve them in an inanimate state for future generations to view in museums?

I cut books. I started carving into them around the year 2000. I was working on a series of collages where I began with newspapers and ended up tearing apart books for a fragmented surface of text on the canvas. I felt guilty about what I was doing, but also intrigued by the deep textures and conceptual potential of

Tower of Babble, 2012. Paperback books, acrylic medium.

the printed page. This led me to seal up books, painting the edges of orphaned encyclopedias—loners from thrift stores—and carving deep holes into them. I was exploring ideas about new ways to approach the pages. At one point I was carving a large hole into a book when I came across a landscape on a page; without thinking I began to cut around the landscape and a figure emerged a few pages below. I carved around that figure and another image appeared. It was exciting because I had no idea what would emerge on the next page. It was like reading. My intuitions were strong and the response was even stronger. I knew I was doing something new and something relevant with old materials. It is recycling, but not just in the material sense; it's a recycling of ideas, images, text, and textures from our cultural past. We pull from the past to make something new, the way art always has.

There has been a long tradition of art about the book, of art representing books, of artists' books, and even altered books; however, in the last five years I have noticed a huge rise in practicing artists and a more interested audience. Most of this book work has emerged as a result of, or a response to, the rise of the Internet and the fact that the role of books has dramatically changed in our current information ecology. Many nonfiction books, specifically reference books, have lost their original function. But I don't think books will ever die. I think it is the perfect form for many of our ideas and stories. The traditional novel, most fiction, large monographs, art, design, and various other genres of text and image are best in book form because of the quality available in print—the tactility, the functionality, durability, and the authority of the object.

Some books may no longer be as vital as they once were, but like painting at the beginning of our last century, it won't be replaced or even demoted in our cultural hierarchy by a newer form. When photography and high-speed printing became commonplace, people feared and prophesized about the end of painting. But instead of suffocating painting, printing and photography freed painting from its pedestrian responsibilities and allowed it to evolve into newer, more modern directions. The history of modern art, led by the new freedoms of painting, wouldn't be the same without these newer technologies for communication. The same is happening now with the book in the digital age. We have an excess of old material we no longer use and an emergence of new ideas about the book. By altering the book, we can explore the meanings of the material and the idea of the book as a symbol for knowledge. We can explore questions about the history and the future of books and the impact of new technology. We can contemplate and illustrate ideas about literature and information technology.

It is not about nostalgia. It is about the richness of its history and the beauty of its form, though more often it goes far beyond this. The infinite ways a book can be explored with our minds and our tools has just begun. We are at an exciting and pivotal moment in the way we record and receive our information. The form of the book, a symbol for ideas, information, and literature, may be the most relevant signifier and richest material we can work with today. We need to take advantage of this moment and respect the history of the book while contemplating its future in the face of shifts to digital technology.

The book is technology. The book is a machine. The book is food. The book is a body. It is a vast pool we need to dive into. ❉

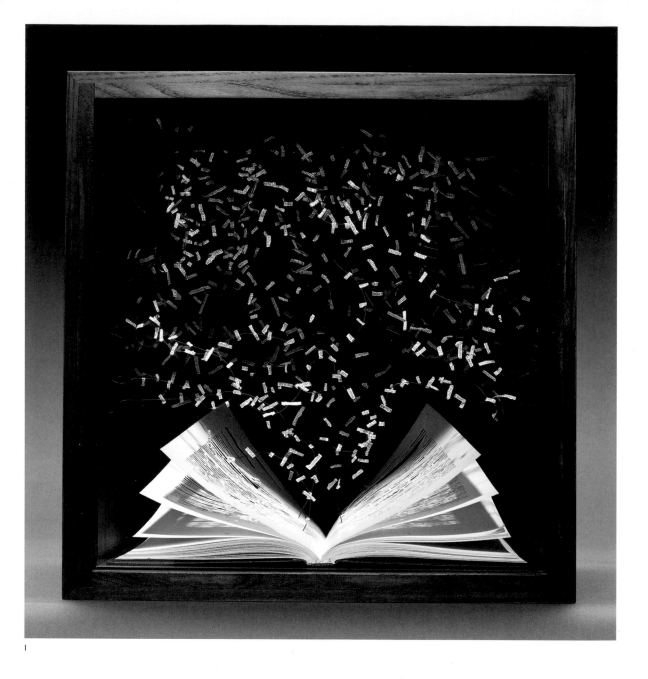

INTRODUCTION

ALYSON KUHN

This anthology showcases the work of artists whose primary material is books. These artists do not make books; rather, they take books apart. Interestingly, a standard nomenclature for this relatively recent art form has yet to emerge. The term "altered books" is widely used by artists and curators, but many members of the art-appreciating public find it misleading. Doug Beube, who has been altering books for more than thirty years, likes the word *bookwork*, which is logical and evocative. Beube sees himself as a sculptor who manipulates books, and he uses the term *mixed media artist* because he also employs collage, installation, and photography. Both Beube and Brian Dettmer, who contributed the preface to this anthology, have pioneered techniques that continue to inspire a new generation of book artists.

Jewelry-maker best describes what Jeremy May does. He crafts rings, bracelets, and necklaces by laminating many, many layers of paper that he cuts with a scalpel from the pages of a single book. Jennifer Collier stitches pages from vintage storybooks, cookbooks, and instructional manuals to fashion her pieces—clothes, shoes, and household objects. In May's work, the original text is obscured; in Collier's, the original narrative literally provides the fabric. Other artists employ, and sometimes combine, elements of origami and paper cutting.

Suffice it to say, the works assembled here are remarkably diverse in form, size, and scale. May's "literary jewelry" and Arián Dylan's paperback chess set are at the diminutive end, whereas Pamela Paulsrud's *Bibliophilism* turns the spines of several hundred discarded books into a huge area rug, and Yvette Hawkins's installations of cylindrical books fill an entire gallery. In between are Vita Wells's airborne cluster of individual volumes, and encyclopedic multivolume landscapes by Guy Laramée and Brian Dettmer.

The artistic alteration of books got its start, with a bang, in the late 1960s. British artist Tom Phillips set himself the challenge of buying a used book and

Su Blackwell, *The Book of the Lost*, 2011.
Secondhand book, lights, glass, wood box.

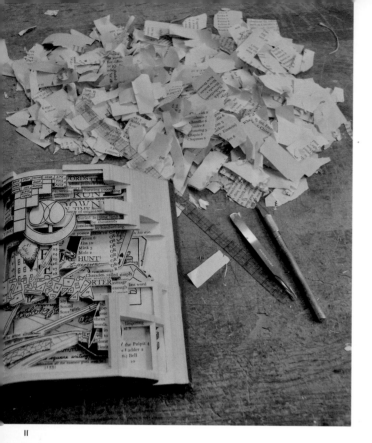

altering every page of it by painting, collaging, or cutting. The novel he purchased was *A Human Document* by Victorian author William Hurrell Mallock. Phillips named his own work *A Humument: A Treated Victorian Novel*. Phillips celebrated his seventy-fifth birthday in 2012, coincident with the publication of the fifth revised edition of *A Humument*. Phillips continues to revise his opus, and to share the work in its entirety on the project's official website (www.humument.com). Phillips has further embraced new technology: a *Humument* app for iPad is now available.

The notion of "treating" a book in this way has historical precedent, albeit more about collecting and less about creating than Phillips's undertaking. Back in eighteenth-century England, the practice of *extra-illustration* became fashionable. As its name suggests, this involved adding illustrations and news clippings from other sources, usually to a biography. So, the original bound text was supplemented by the owner, who then possessed a uniquely curated edition—an interesting variation on vanity publishing. For a time, publishers actually included blank pages to accommodate such additions; with other books, an owner would have the original volume unbound and then rebound. *The Biographical History of England* (1769) by the Reverend James Granger was so popular with extra-illustrators that this practice became known as *grangerism*.

Today, reference books that have outlived their usefulness as sources of information are treasure troves for contemporary book-altering artists. Volumes with patterned, stamped, or otherwise embellished covers also have potential. Occasionally, a self-help book, a telephone directory, or a scientific report may become fodder for a bookwork. Some book lovers are uncomfortable with the notion of altering books to make art. We are taught as children to respect books, to treat them with care. Yet, many of us find their contents so personally meaningful that we write notes in the margins or even highlight entire passages. We may dog-ear the pages of a paperback to mark our place. Author Anne Fadiman, in her essay "Never Do That to a Book" (from *Ex Libris: Confessions of a Common Reader*), divides book lovers into two categories, the "courtly" and the "carnal." The

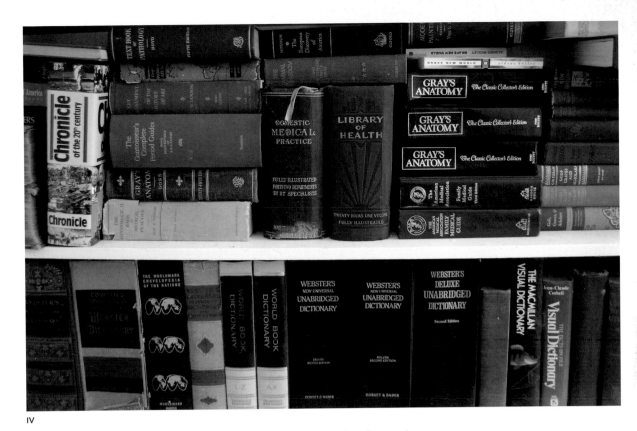

IV

courtiers, if you will, treat books as sacred objects; the carnal readers make notes in, and take other liberties with, their books. Both groups love their books, but show it differently.

Altered books tap into our collective heightened interest in books as objects. Physical books, as differentiated from digital versions, tend to trigger memories, both visual and tactile. Our eyes read a book, our hands feel it and hold it, and our muscle memory deepens our relationship with it. Some readers keep the receipt for a book right inside the front cover, especially if it was purchased on a trip. Many shops automatically slip their bookmark into a book. Handheld embossers, bookplates, and rubber stamps are all popular ways to identify your book as yours.

Then, when we are finished reading a book, we decide whether to keep it or lend it or re-gift it. We may take it to a used bookstore, or sell it online, or donate it to a library sale—where book-altering artists find their raw materials, and give them new life.

Imagine that you are an author, and one day you receive as a gift a copy of your first novel, but it has been physically altered to the point where it is no longer possible to actually read the story. This happened to writer Jonathan Lethem several years ago. The book was *Gun, With Occasional Music*, and it had been cut into the shape of a pistol by artist Robert The, whose work Lethem describes as "the reincarnation of everyday materials."

II

Brian Dettmer, process shot.

III

Brian Dettmer's collection of used X-Acto blades.

IV

Two of the many bookshelves in Brian Dettmer's studio.

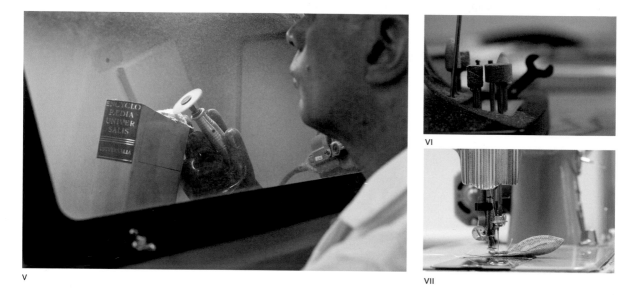

V

VI

VII

The writer reflects on this "strange beauty of second use" in an article published in *Harper's Magazine* in 2007, concluding "the world makes room for both my novel and Robert The's gun-book. There's no need to choose between the two." The artist has made other gun-books, including one from *The Medium is the Massage* by Marshall McLuhan and Quentin Fiore (p. 164).

More and more art galleries have begun to show altered books. One gallerist who has featured these works, both in an annual *Art of the Book* exhibition and in the occasional solo show, is Donna Seager of Seager Gray Gallery. She feels these works evoke, first and foremost, surprise—and then curiosity and delight.

A book is a highly familiar and beloved form. When it is altered, so many associations are called into play, including the deep relationship we have with books in general and with certain books in particular. Some people's initial reaction is horror at the evisceration of a sacred or precious object, but then the fertile field that a book can be as material for art becomes evident. Content and form—and our attitudes or perceptions—are manipulated at the same time. The work engages not only the eye, but also the intellect, allowing for powerful commentary in concert with extraordinary visual appeal.

V

Guy Laramée using a sandblasting cabinet to contain the dust.

VI

Jeremy May's sander bits for his rotary tool.

VII

Lisa Kokin's sewing machine.

VIII

Thomas Allen, process shot.

IX

Jennifer Collier finishing a pair of shoes.

In the summer of 2012, the Christopher Henry Gallery in New York mounted an international exhibition titled *A Cut Above: 12 Paper Masters*. Four artists whose work appears in this book were included in that show: Doug Beube, Brian Dettmer, Guy Laramée, and Pablo Lehmann. Through spending time with their work, co-curator Diana Ewer observed that by transforming a book into a sculpture, the artist in a sense permits the book an alter-ego.

These artists turn books into new objects within their own right, 2-D and 3-D sculptural works that evoke a visual pleasure and also challenge our own understanding of what a book has been and what it should be. The artists play on our familiar experience of the book, turning it on its head by cutting, sawing, shredding, and stitching specific books remembered from childhood as sacred cultural artifacts! We are engaging with something that is intellectual and to an extent political. These artists are agents of change, inviting us to confront and question how we understand and process knowledge. Whilst we continue to remain aware of books' original purpose—bookworks have an immediate poignancy as the Internet surpasses printed material as our primary focus for obtaining information and, for many people, seeking entertainment.

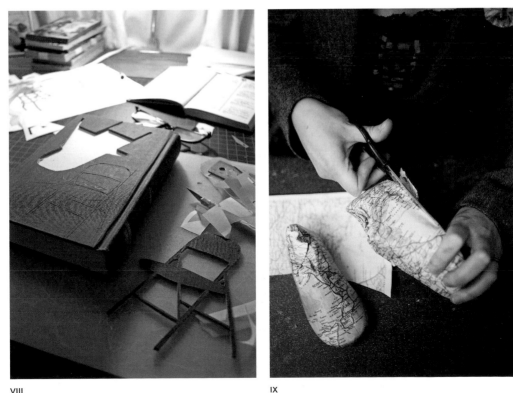

VIII IX

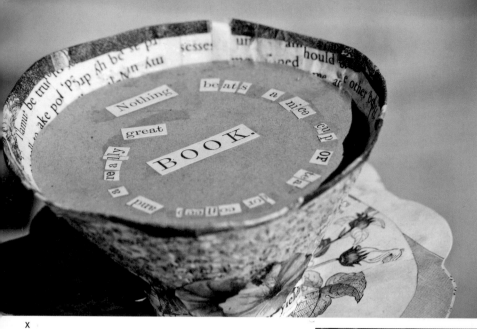

X

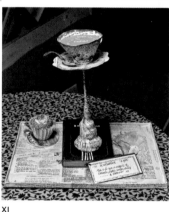

XI

XII

This anthology includes an anonymous art-ist, someone who has chosen to receive no per-sonal recognition or compensation for the ten bookworks she made (she has revealed herself to be female) and mysteriously left at libraries and other cultural centers throughout Edinburgh in the course of 2011. The pieces share a sense of creative abandon or frenzy or tatter—as if they have weathered a storm or a tempest in a Mad Hatter's teapot. They have been widely acclaimed in print, and the attention they generated in the blogosphere is quite fitting, as each piece bore a handwritten gift-tag addressed to the venue's Twitter name. The outpouring of aesthetic delight and moral support from library lovers is a fine testimo-nial to the growing awareness and appreciation of altered books as an engaging way to illustrate the wonders of reading.

X, XI

Anonymous, *@edbookfest* (6/10), 2011.

This was made for the Edinburgh Interna-tional Book Festival. Really, is there anything nicer than a cup of tea, a cake, and a lazy afternoon with a book? —Anonymous

XII

Anonymous at work in her studio.

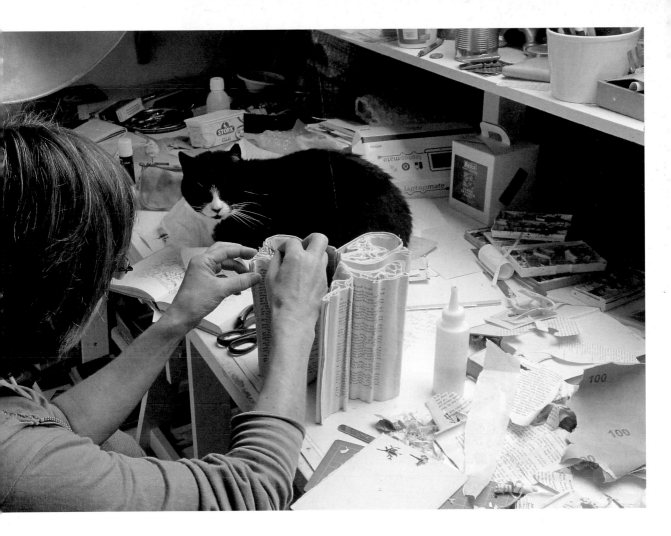

ANATOMY OF AN ALTERED BOOK

One way of reflecting on the diversity of these artists is by considering which part or parts of a book they work with. For photographer Thomas Allen, the proverbial "Don't judge a book by its cover" is the exact opposite of his approach. The first book he ever altered, at the age of five, was a *Better Homes and Gardens* storybook, onto whose inside back cover he traced the outline of his hand. Today, forty-some years later, Allen uses the front or back covers of books, and the occasional inside spread, as his blank canvas. He specializes in liberating people or things from the covers and letting them stand up or fly off or play basketball on their own. In *Rhyme & Reason*, inspired by Norton Juster's *The Phantom Tollbooth*, Allen uses a perfect pair of well-worn books (p. 32). He cuts two characters, who step out gracefully from their covers, elegant skirts flowing. (They would be the best of bookends.)

"Criminality and insanity are plants which spring up from the same soil of physical and mental degeneration."

Mike Stilkey also specializes in altering covers, but collectively rather than individually. He arranges a shelf or stack or wall of books, and then paints a scene or portrait over the spines. The same brooding black-clad couple appears in several works, always looking Bohemian and bookish. In *Lovers All Untrue*, a book's original cover becomes a carpet, atop which a neatly dressed horse-man plays a green accordion that matches the chair he's standing on, his mane disappearing into the back cover of a book about Abraham Lincoln (p. 147).

In her series *Still Standing*, Vita Wells turns book spines into skeletal spines. She arranges them by color into towering columns: shades of red, gradations of blue, a continuum of neutrals. Each column is stacked on a wood and metal "shoe." The volumes have been sanded convexly, so their contents are bulging out. Usually, hints of text are visible along the edges, and the ink patterns with cream borders suggest printed textiles, another of Wells's interests. In one of the nine figures constituting *Still Standing*, the artist presents wordmarks (logos or trademarks made from letters) from decades past of publishers who are themselves still standing (p. 166).

An altered book can still look like a book even if much of its content has been removed. The missing—or the remaining—content suggests a new narrative, one that may either replace or reinforce the writer's original intent.

In some of her pieces, Noriko Ambe focuses her alterations on the "interior geography," a recurrent notion in her work. For *To Perfect Lovers: Felix Gonzalez-Torres*, the artist has meticulously carved two copies of the same book, enticing the viewer to try to find the differences (p. 40). Ambe's tiny circular cuts are light and lacy, evocative of a crocheted doily or a millefiori paperweight, but the text that remains on the page suggests a different scenario. It presents two 1996 entries from a chronology documenting the AIDS epidemic: the first one announcing the death of Felix Gonzalez-Torres in Miami; the second a breakthrough in protease inhibitors. Within this context, the nonidentical cuts reveal mutating cells under a microscope, or even a crater of despair. But if we could only close the book, everything would seem fine.

Jeremy May is a landscape architect turned jeweler. He transforms vintage books into jewelry boxes to hold the rings, pendants, and bracelets that he makes by laminating hundreds of little sheets of paper together—little sheets that he has carefully cut out of the book in question. The first piece he made, back in 2007, was a ring for his wife for their first anniversary, the paper anniversary. It took May almost two years of experimenting

XIV

xv

to perfect his secret laminating technique before going public as Littlefly in 2009. Works of fiction, nonfiction, and poetry are all suitable, as long as the book is thick enough to allow May to carve a recess for the finished piece.

The original book structure can also become a window, a frame, or a stage. Some artists start by cutting the cover and then working their way in. In fact, James Allen describes his works as *Book Excavations*. He cuts into the cover of vintage books and carefully delves down, one page at a time. As he goes more deeply, Allen reinterprets the book's subject by selecting elements for his own visual narrative. What was originally linear or sequential is now layered and simultaneous. In *Dresses*, 2010, he excavates elaborately attired ladies from centuries past, all with elaborate coiffures or headdresses (p. 24). His selective history of women's fashion at-a-glance leads the imaginative viewer to fantasize about the surreal tea party or literary salon at which these ladies found themselves juxtaposed.

Gray's Anatomy has inspired several artists, with its myriad of illustrations and its potential for wordplay. For *Double-sided Gray's*, Julia Strand performs an intricate dissection of the classic anatomy text, cutting through both the front and back covers to expose skeletal elements, organs, and other body parts—all of which appear to be floating independently (p. 156). Several of Strand's other works involve cutouts of butterflies, a perfect double metamorphosis.

Nicholas Jones sometimes uses graphic elements on a cover as his point of departure. In other works, he cuts the cover to create a silhouette or a shoreline. For *Gedichte*, the artist gently reconfigures a vintage volume of poetry (p. 90). His folds are crisp, precise, and from the deliberation emerges a new lyrical form. The poems are suspended in midair, like a pirouetting skirt in slow motion. The words we cannot read cast a petaled or plumaged shadow on the endpapers.

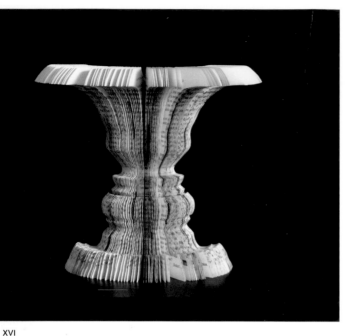

Arián Dylan, *Autorretrato gritando* (Self-Portrait Screaming), 2010. Trimmed book (laser and hand). Note the pair of symmetrical silhouettes created by the background.

Kylie Stillman, *Common Oak*, 2007.

Cara Barer, *Shiitake*, 2007. Archival pigment print on rag paper. (*Who's Who*, 2003)

Kylie Stillman often uses the fore edge of books—the part that faces inward when a book is shelved—as her point of entry. She secures a stack of books to create her cutting block, and then carves out a bird, a branch, or a flower in a pot. The contrast of field between the plant and its container can be hypnotic. In *Hanging Basket—Fishbone Fern*, the pot hangs on its three strands of chain from a trompe l'oeil hook Stillman has carved into the uppermost two volumes in a tall stack (p. 151).

Some artists specialize in flipping books inside out, which can turn the pages into a cylinder. By folding each successive page in on itself in exactly the same way, Yvette Hawkins creates jewel-like little sculptures. In her installation *No Land in Particular*, 2010, she arranges hundreds of cylinders into a dense landscape of orderly tree stumps, or perhaps they are new shoots, which then start climbing up the gallery wall, forming a DNA chain of literary creation (p. 80).

Arián Dylan sculpts the edges of paperbacks and then turns them inside out to create forms that look like smooth little orbs or ornaments or fruits. When hung together, they suggest a galaxy or a succulent garden. Dylan uses the same technique in *The Order and the Chaos*, a full set of chess pieces on a board (p. 79).

Other artists alter books to a point where the pages take on a life of their own, as sculptural objects that are more like fireworks, exotic flora, or ethereal creatures. Given that the base material is usually a damaged or

discarded book, the transformation is as dramatic as that of an ugly duckling into a swan, or even a frog into a prince. Cara Barer entices book pages to behave like vibrant, flowing fabric and then suspends them in mid-maneuver. They are crimped, undulated, curled, and scrolled—and they seem to defy gravity. The most humble directory can become a resplendent butterfly or a whirling dervish. Colored edges make them seem like they are dressed up for a performance, though some of Barer's pieces suggest that the dance might be over. Barer photographs her works, which means that the viewer cannot walk around them, but the artist presents the perfect angle.

Jacqueline Rush Lee reformats books into petals, leaves, and exotic flora that showcase the symmetry of nature. The artist spirals directories into a cross section of a log or a plant stem—from which they originally came—or an aerial view of an island. In some works, pages have gently rolled in on themselves; in others, they undulate in an invisible crosscurrent.

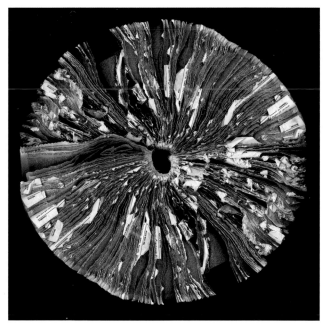

Reference books are a brilliant raw material for works exploring how we obtain, preserve, and share information. Frequently, the titles of these works reinforce the theme. In many of his pieces, Doug Beube reflects on the ways in which language is used to hide or reveal intentions. He has created a series of masks, each carved on a band saw from an entire dictionary, using a stencil he has made in advance. The success of the cut is not a given, which is why Beube keeps plenty of dictionaries on hand. Once cut, the book is literally turned inside out to get the configuration. For *Masked Words*, 2011, Beube made a hairpiece out of another book, slicing it into strands on a guillotine cutter, then collecting the strands into a bundle. When Beube exhibits a pair of masks together, only one wears

XVIII

a hairpiece—and it's not gender-specific. The hairpiece is removable and, in theory, interchangeable, which might hint at how easy it is to talk off the top of your head (p. 55).

Lisa Kokin has recently turned her attention to self-help books. Sometimes, she cuts the covers up and stitches them into leaves and petals. Kokin's parents were upholsterers, and she is handy with a sewing machine. She's also taken to reducing books back to their raw form, which is to say paper pulp. Kokin compacts the pulp into stones or balls or nuggets and usually configures them with a book that is still whole. Some

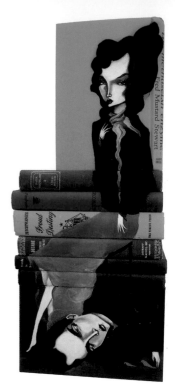

XIX

highly condensed information—or even elemental gray matter—seems to be oozing out of *The Famous Roth Memory Course*, suggesting that the reader's stream of consciousness can indeed overflow its banks (p. 101).

Alex Queral and Guy Laramée both use a book as a block of material, but their sourcebooks are "information opposites." Queral uses discarded phone books, which are ultra-disposable, even ephemeral. He carves relief portraits out of them, transforming thousands and thousands of anonymous listings into a single, highly recognizable face, with features enhanced by the use of shadow. Laramée uses very substantial old reference books, especially dictionaries, to carve scenes out of the tops. His more-or-less green landscapes offer mountain meadows and peaks, sometimes with a tiny shelter or refuge. Laramée has also expressed the impact of a volcano or a tsunami in his altered books, reflecting changes in the natural and the intellectual climates.

Pamela Paulsrud uses old books as elements in her mixed-media sculptures, often adding her own calligraphy, drawing, or painting right on the cover, or onto a

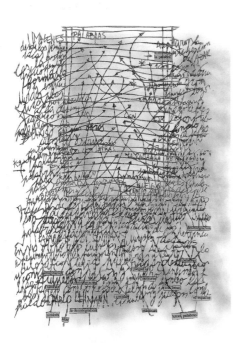

XX

separate panel that she attaches. Bits of other texts or ephemera find their way into her compositions, sometimes visible through a little window. Paulsrud occasionally mounts a piece on a caster, suggesting that it is headed somewhere—like a bookmobile.

Some artists work with individual pages removed from a book, and the page may or may not remain readable in its new incarnation. Susan Porteous takes books completely apart and converts their content into part of a sculpture that frequently includes wood or stone. In one series, she twists pages into paper twine and winds it around an old spool. She might be spinning a new yarn, or twisting the original meaning, or simply losing the thread of her story. In *Bridge Complete*, folded pages are compressed to form a suspension bridge between two rocks, overlooking an information gap, or even an abyss (p. 127).

Jennifer Collier takes books apart and then stitches selected pages together as something altogether different. There's method in her whimsy: for each creation, Collier uses a book that corresponds to the finished piece, frequently an item of clothing or a kitchen accessory. A vintage typing manual provides all the parts for her *Paper Typewriter* (p. 68). Collier's platen is made from illustrations of proper typing posture; typical typing exercises of their day form the outside of the machine. Readers all over the world have noted Collier's black-and-white paper dress, with red paper shoes, on the cover of *The Thoughtful Dresser* by Linda Grant.

XIX

Mike Stilkey, *Time and Time Again*, 2010. Acrylic on books. Exhibited at Bristol City Museum, Bristol, United Kingdom.

XX

Pablo Lehmann, *Game Text 1*, 2006 (detail). Canson paper printed with an excerpt from *Images and Words* by Horacio Zabala and cutout with text from the same title.

XXI

Vita Wells, *Flights of Mind*, 2012 (detail). Books, filament. Installation at Oakopolis Gallery, Oakland, California.

XXI

Georgia Russell cuts pages into plumage or tendrils or veins. In some works, the feathers or shards push their way out from behind their original beautiful cover. In others, Russell cuts the cover in a way that underscores the subject; sometimes only the title remains intact as the rest of the cover melts or flows away. When Russell mounts a piece in an acrylic case or glass bell jar, it's as if she has taxidermied an exotic bird or preserved another fragile species.

It's possible to send a meaningful and engaging message by cutting individual letters out of, or into, a text. Pablo Lehmann specializes in individual letterforms, cutting a new text, one letter at a time, out of another. In some works, the characters are instantly identifiable, though the words or sentences may remain disjointed. In other works, the artist seems to be writing a message in a personal alphabet of script-like swooshes. Sometimes, the original page is still readable around or behind Lehmann's text; other times, several layers overlap, like a succession of gossamer curtains through which we can vaguely sense a shadowy form.

Su Blackwell's cutting work is delicate in a different way from Pablo Lehmann's. Blackwell is known for book tableaux that bring to life a scene from a fairy tale or folk story. A landscape of trees, a little dwelling, perhaps some birds, and maybe even an instantly recognizable heroine, all rise up off the page. Snippets of words may shiver in an imaginary breeze or float into thin air or even be swept away by a tiny broom.

Jennifer Khoshbin also uses children's books, or other books onto which she places children; sometimes these figures get to play like children and sometimes they do not. Khoshbin cuts small precisely placed concentric circles into a book, tapering down to a single word at the bottom: *face* or *rescue* or *life*. In *Look*, on a slightly spooky night, three young boys clamber off their endpaper, bound for one of Khoshbin's holes (p. 93). Down they go, and we will never know what happens next.

XXII

Georgia Russell, *Les Paravents*, 2011, a play by Jean Genet. Cut book jacket in acrylic case. *Paravents* is French for screens.

XXIII

Book fragments in Anonymous's studio.

Robert The frequently seems to revel in the interplay of positive and negative space. Cutting an object out of the entire thickness of a book, he creates a two-part puzzle that is mysteriously humorous or thought-provoking, especially when The shows us the book from which a big bug or crustacean has liberated itself. In his *Tractatus* series, The has cut a large oak leaf through a weathered volume, *Tractatus Logico Philosophicus* by Ludwig Wittgenstein. He scatters the leaves in the forest, where they seem right at home (pp. 160–161).

Brian Dettmer rarely confines himself to one book at a time. Encyclopedia sets and multivolume dictionaries frequently come under his knife, as he excavates images by excising the surrounding parts of each original page. *I Could Tell You* is composed of books from a different genre: fifty-three paperback mysteries, combined and sanded to create one large beam of information (p. 74). Dettmer has carved the open-ended phrase "I could tell you but then I'd have to" into the smooth surface. Each cutaway letter reveals hundreds of individual words from the underlying books, exposing the inner secrets of the mysteries, but in a fragmented way. Bits of revealed words around the main text suggest bits of data or the punch-card system of early computing. Foreboding, as well as beauty, is in the eye of the beholder.

The works of the artists in this anthology have been seen, and will continue to be seen, in galleries and museums around the world. Thanks to the Internet, many of them are also viewable on the artists' own websites. Some of the people who look at them may do so with nostalgia for the original books' earlier lives. Others may have had little use for them as books. People on both sides of the "margin" can be engaged, touched, and even inspired by them as art. It's exciting to think about. ✳

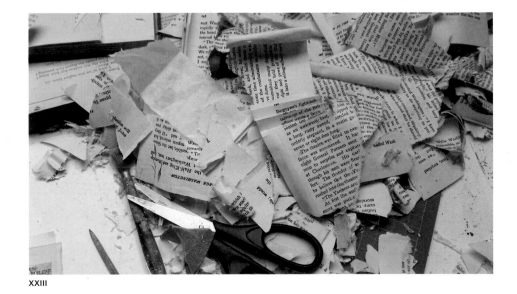

XXIII

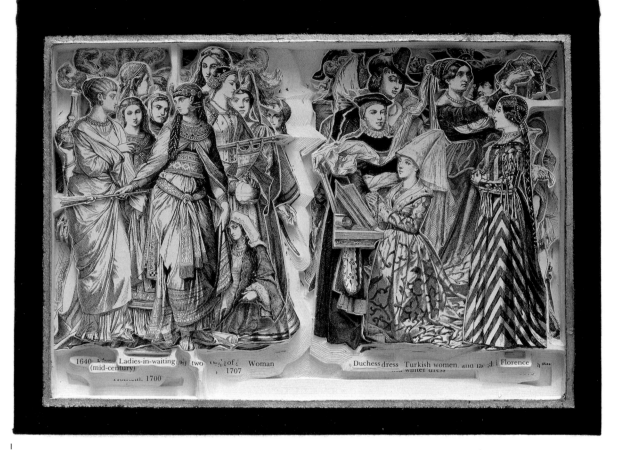

1640. Ladies-in-waiting two of Woman
(mid-century) 1707
Holland, 1700

Duchess dress Turkish women, and lace Florence
and winter dress

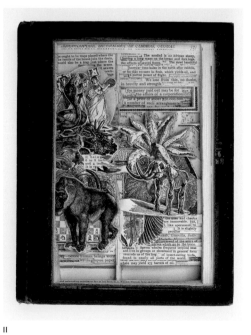

JAMES ALLEN

I

Dresses, 2010. *(Historic Costume in Pictures)*

II

The Army of Nerves Which Go to the Brain, 2011. *(Everybody's Encyclopedia)*

One page at a time, **JAMES ALLEN** cuts his way through books. He begins by creating an opening in the cover; he then uses a reductive process to shape elaborate scenes, cutting away sections of each page to reveal layers underneath. The book remains bound and the pages intact. By selectively keeping fragments of images and words, Allen's *Book Excavations* come together as the content emerges. Allen considers both narrative and compositional dynamics of each book to form his condensed reinterpretations. In doing so, he destroys the original intent of the book and creates a new, visual meditation on its subject.

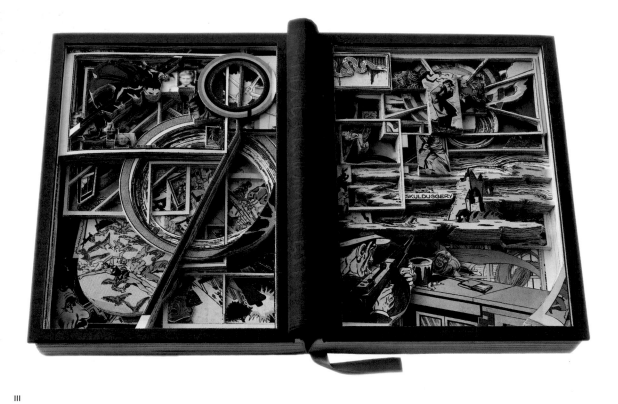

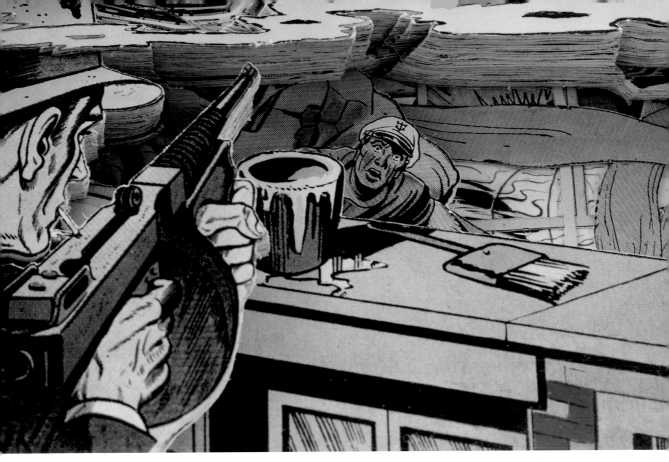

IV

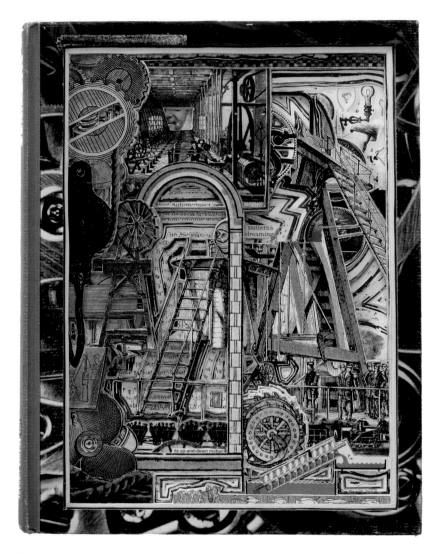

v

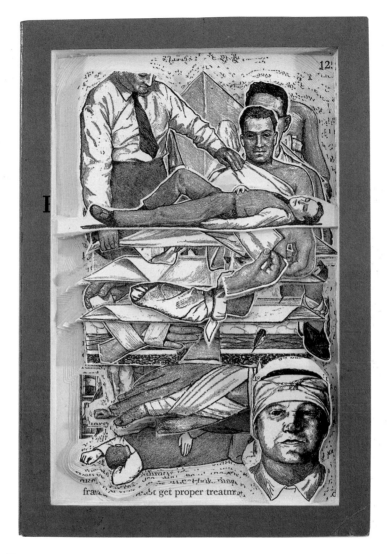

V

Pattern Dreaming, 2009.
(Machines)

VI

Proper Treatment, 2009.
*(American Red Cross
First Aid Textbook for Bell
Telephone Employees)*

THOMAS ALLEN

I, II (OPPOSITE)

Stuart Little, 2011.

A weathered and discarded copy of E. B. White's classic, *Stuart Little*, was gently manipulated to make big pictures of a little mouse.

THOMAS ALLEN has been altering and photographing books from a variety of genres, including primary readers, dictionaries, and pulp novels, for twenty years. In 2011, Allen was asked to create a series of unique works of art for prominent public spaces within the Charlotte R. Bloomberg Children's Center at The Johns Hopkins Hospital in Baltimore, Maryland. He chose *Stuart Little* by E. B. White, *The Phantom Tollbooth* by Norton Juster, and *Hoops*, a young adult novel by Walter Dean Myers. For each book, Allen carved silhouettes on the covers and pages and then photographed the works for display; in the case of *The Phantom Tollbooth*, Allen selected different titles that evoke aspects of the characters depicted.

"Don't look down," replied Margalo. "Then you won't get dizzy."

"Suppose I get sick at my stomach."

"You'll just have to be sick," replied ... "Any thing is better than de..."

"Yes, that's true ..."

"Hang on, ..."

Stuart ...

gerly ...

M...

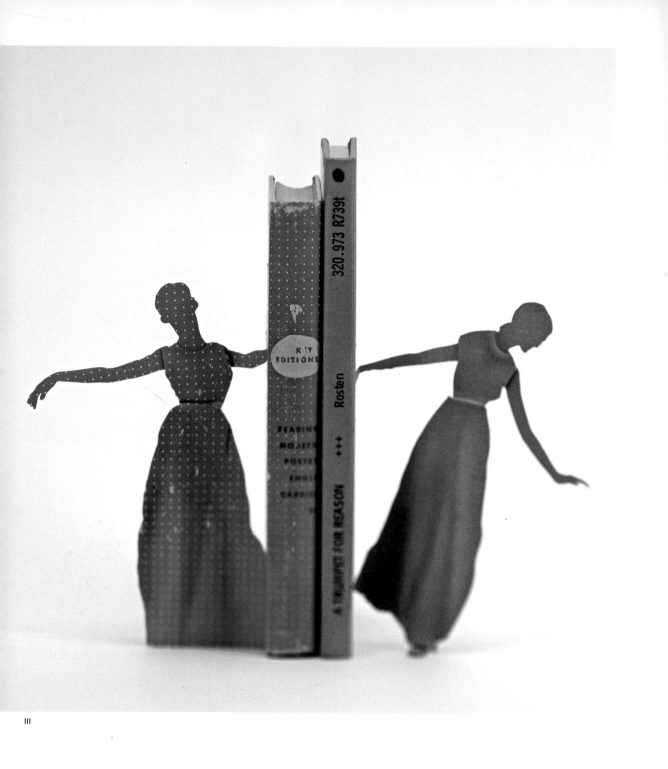

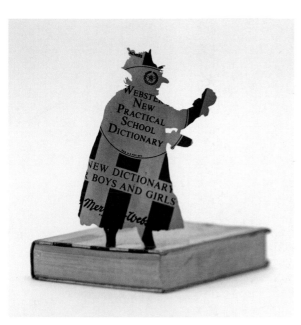

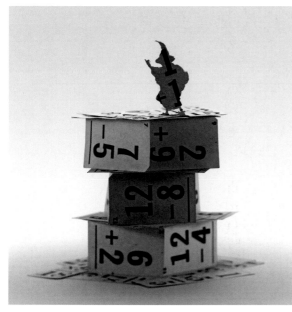

III

The Phantom Tollbooth, 2011.

Inspired by idioms found in *The Phantom Tollbooth* by Norton Juster, reference books become some of the characters: *Rhyme and Reason, King Azaz, The Mathemagician, Tock.*

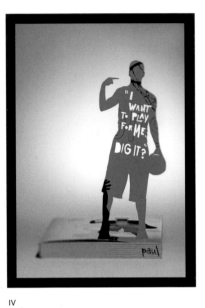

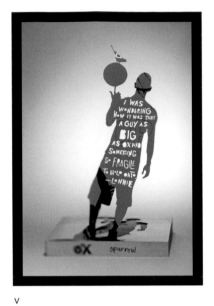

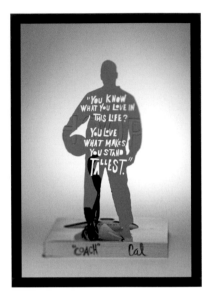

IV V VI

IV–IX

Hoops, 2011.

Characters from Walter
Dean Myers's novel about
inner city teens appear as
silhouettes in the covers
of six copies to reveal
positive messages with
words shaped by negative
space.

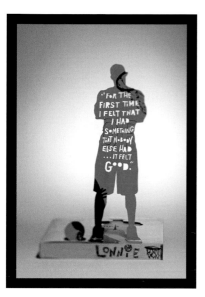

VII

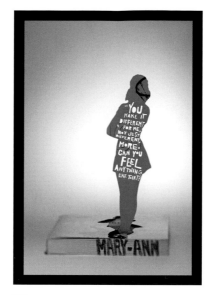

VIII

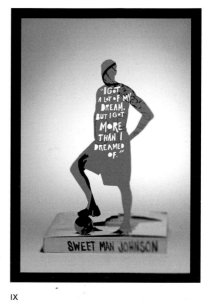

IX

I

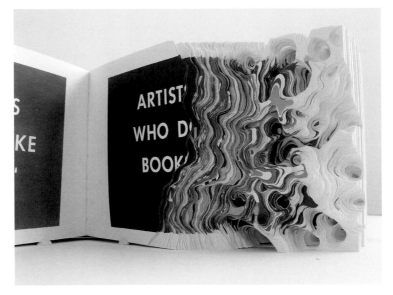

II

NORIKO AMBE

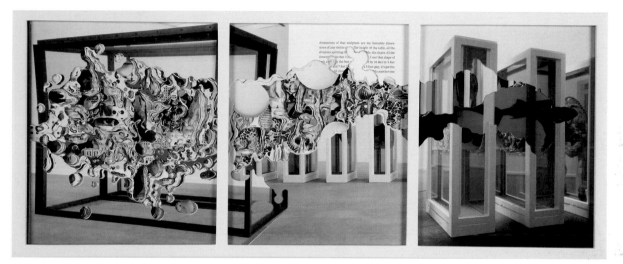

III

———

For **NORIKO AMBE**, cutting books is a collaboration between the artist and the images or text already on the page's surface. Recognizing that printed matter conveys a specific message, she chooses her materials carefully. Just as the structure of the book straddles the line between two and three dimensions, Ambe creates work that hovers between drawing and sculpture. Her cutting plays against the preset patterns, and even though the physical action is simple, she doesn't try to perfect the lines in her work. In the artist's words, "Subtle and natural distortions convey the nuances of human emotions, habits, or biorhythms." For this reason, Ambe meticulously makes all her works by hand.

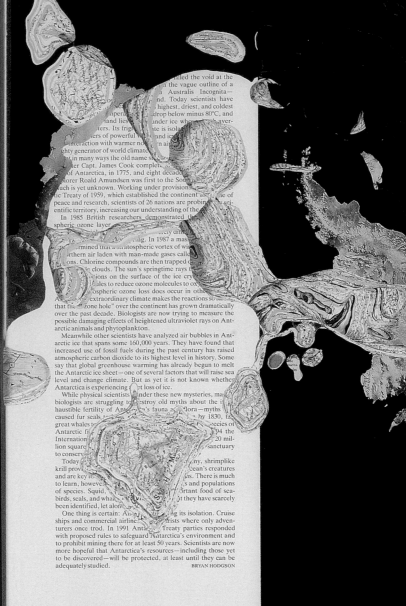

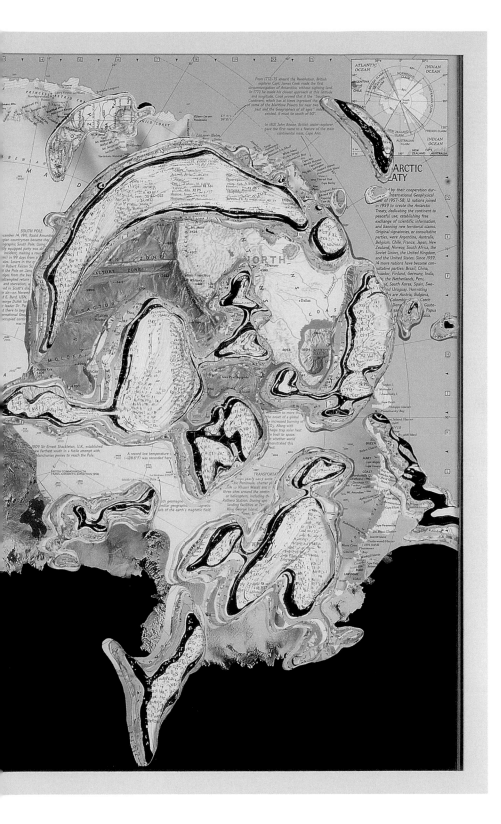

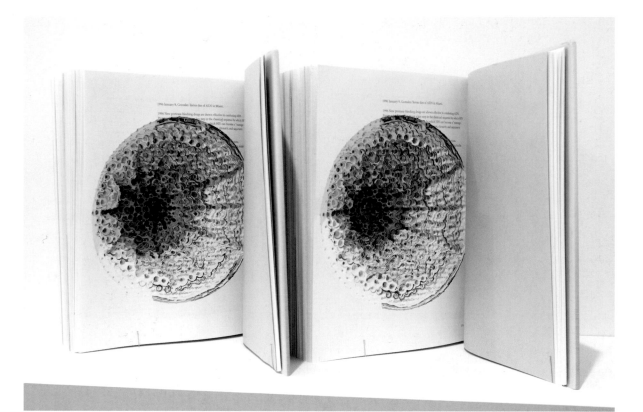

V

V

To Perfect Lovers: Felix Gonzalez-Torres, 2010.

VI

The Sand–The Americans: Robert Frank, 2011. Book, Plexiglas.

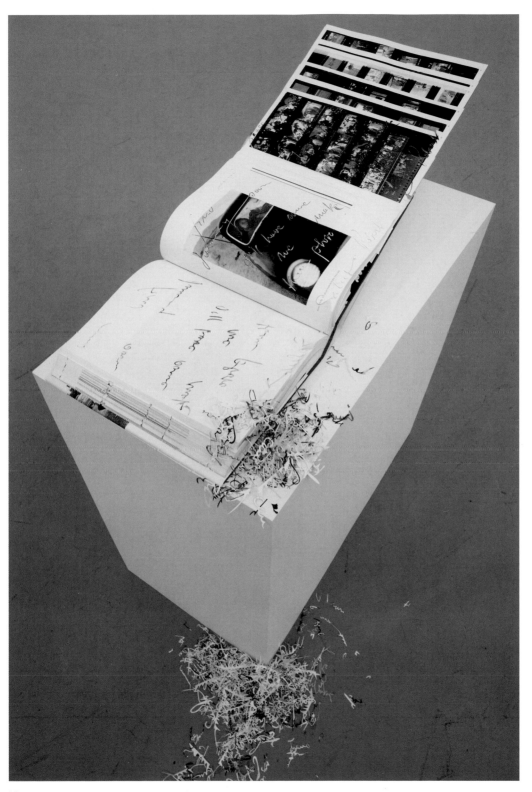

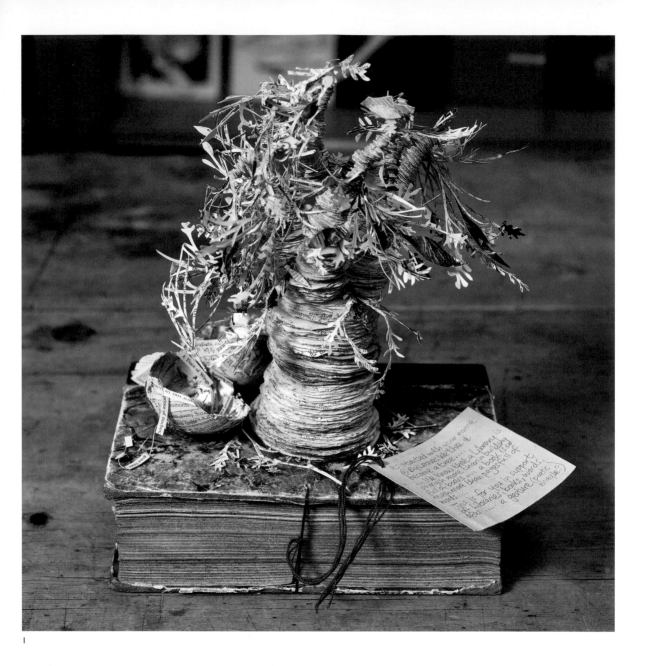

ANONYMOUS

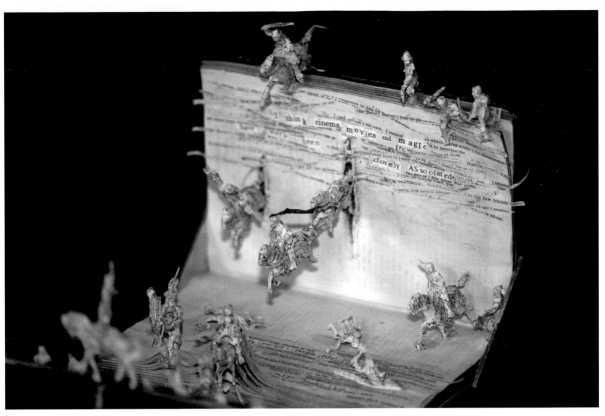

II

@byleaveswelive (1/10),
2011.

Popularly called *The
Poetree* and inspired by
The Scottish Poetry
Library's tagline "by
leaves we live." The poem
inside the eggshell is
Edwin Morgan's *A Trace
of Wings*, lamenting the
loss of his friend Basil
Bunting, "a rare bird."

II

@filmhouse (3/10), 2011.

A sculpture was left at
Edinburgh's Filmhouse to
celebrate a great venue,
invaluable to those who
also enjoy their books on
the big screen.

Over the course of eight months, from March to November
of 2011, ten small book sculptures bearing tags "In support of
libraries, books, words, and ideas" were smuggled into various
cultural venues around Edinburgh. Although the artist has
remained **ANONYMOUS**, the beauty of both the work and the
mystery surrounding it has gained renown. While the individ-
ual sculptures are made from old paper and books, the project
is interwoven with new technology, with each gift addressed to
the venue's Twitter name.

The only books used that were written by a living author
were *Exit Music* and *Hide and Seek*, both by Edinburgh's Ian
Rankin. In what seemed only a fair exchange, sculpture 11/10,
@beathhigh, was the single work not gifted to an institution but
to Ian who, according to the artist, is arguably an institution.

Chris Scott, who became chief recorder, photographed
and blogged each sculpture as it appeared, providing the story
with an online home. He became a vital collaborator, although
he and the artist have never met.

III

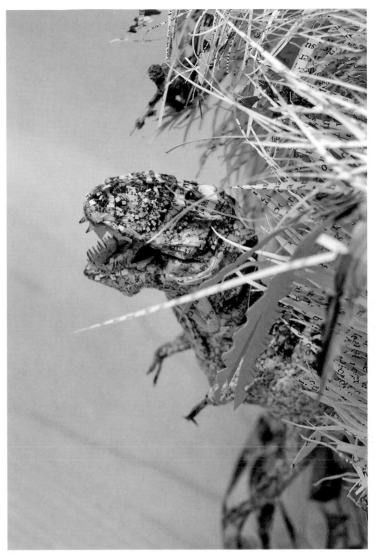

IV

III

@curatoremg (8/10), 2011.

The Writers Museum pays tribute to Edinburgh's literary heritage. In this sculpture, "Dr. Jekyll and Mr. Hyde" is crafted from Ian Rankin's novel *Hide and Seek*, and two of Edinburgh's literary sons are giving a nod to each other.

IV

@ntlmuseumsscot (9/10), 2011.

It would be wrong of me to take credit for the idea of placing Arthur Conan Doyle's *The Lost World*, complete with a T. rex, into Edinburgh's National Museum. This I think came from photographer Chris Scott. It worked well. Dinosaurs are cool, and museums, like libraries, are free, fascinating, and beyond value.

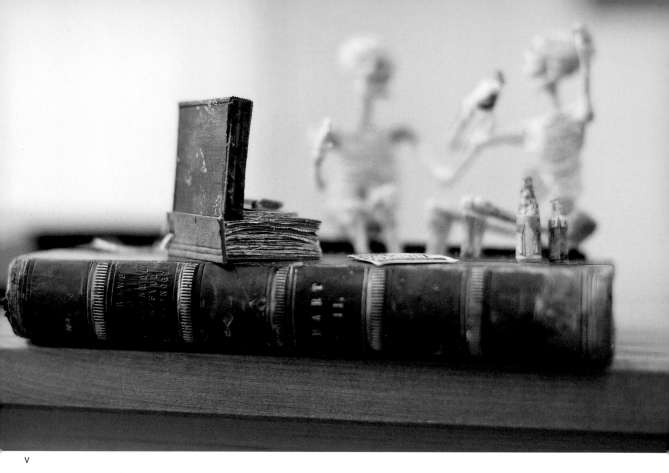

V

V, VI

@beathhigh (11/10), 2011.

This was made for @beathhigh (Ian Rankin) to mark the publication of *The Impossible Dead*, and as a thank you for his support throughout the project. Via Twitter, he was in on the idea from the beginning and served as a sounding board throughout.

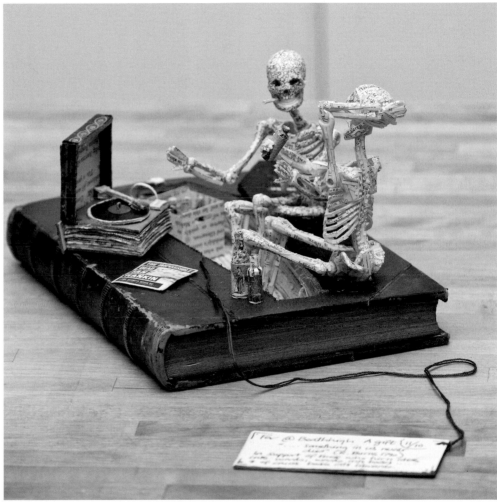

VI

I

Elegy, 2011. Archival pigment print on rag paper. (*Enigma* hardback novel)

II

Corset, 2007. Archival pigment print on rag paper. (*Norton Anthology*)

III

Leap, 2004. Archival pigment print on rag paper. (Photoshop 5 computer manual)

CARA BARER

CARA BARER blurs the line between object, sculpture, and photography. She first finds discarded or obsolete books, and by using water and various clamps, string, staples, and glue, transforms them into sculpture. She then photographs them, capturing the extraordinary grace and beauty of their altered form. Barer's sculptures and their accompanying photographs are a lament for eras past when books were considered much more valuable and a path to knowledge. As books are becoming increasingly disposable, replaced by the Internet as a primary source of information, Barer hopes to raise questions about these changes, about the transient and fragile nature in which we now choose to obtain knowledge, and about the future of books.

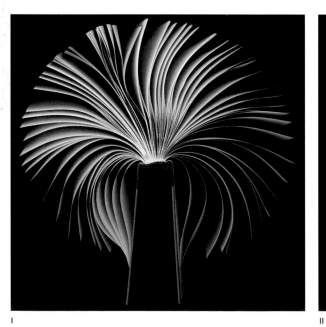

I

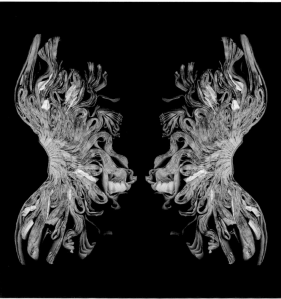

II

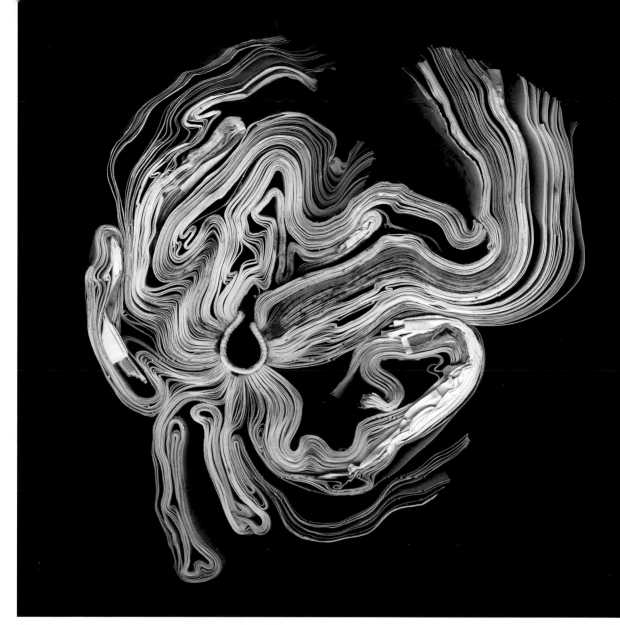

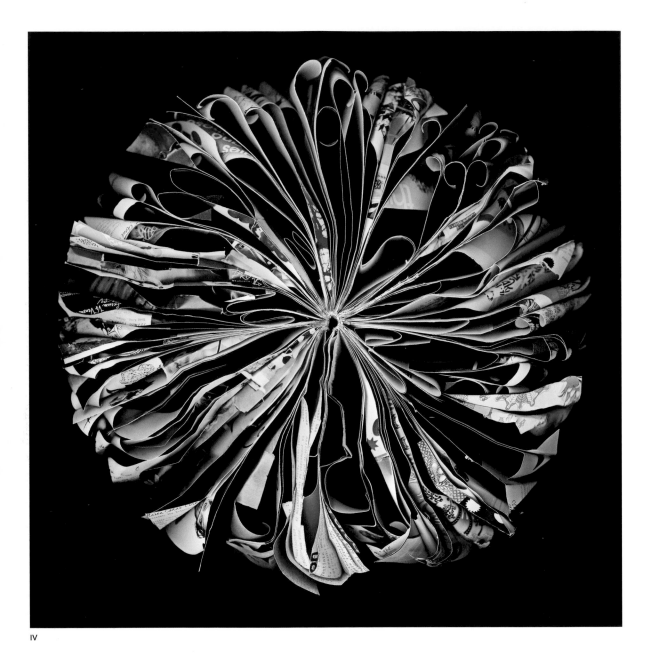

IV

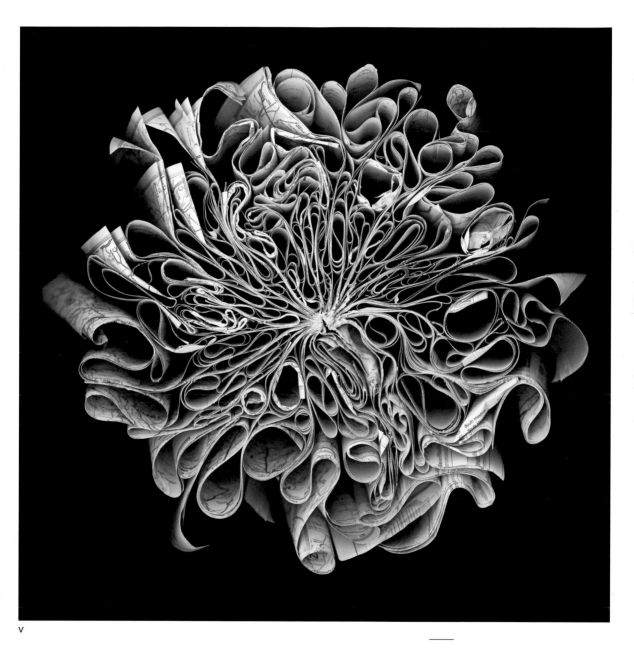

V

IV

Fashion, 2011. Archival pigment print on rag paper. (Book on graphics in Japanese fashion)

V

Explorer, 2011. Archival pigment print on rag paper. (*The Ultimate Road Atlas*)

51

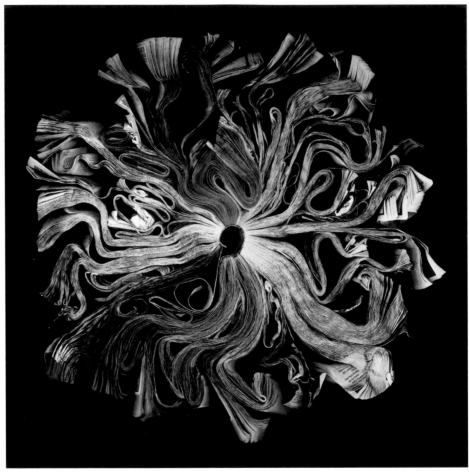

VI

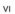

VI

Carmen, 2007. Archival pigment print on rag paper. (Houston Yellow Pages)

VII

Bundle, 2010. Archival pigment print on rag paper. (Texas A&M Directory)

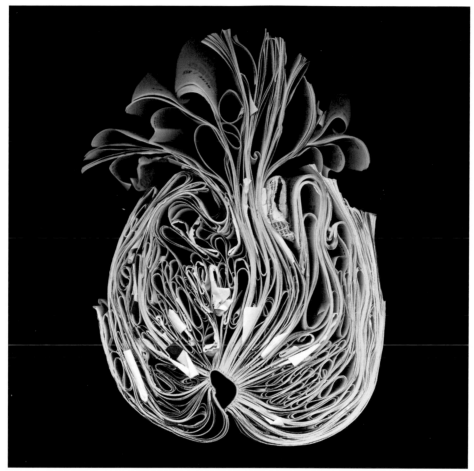

VII

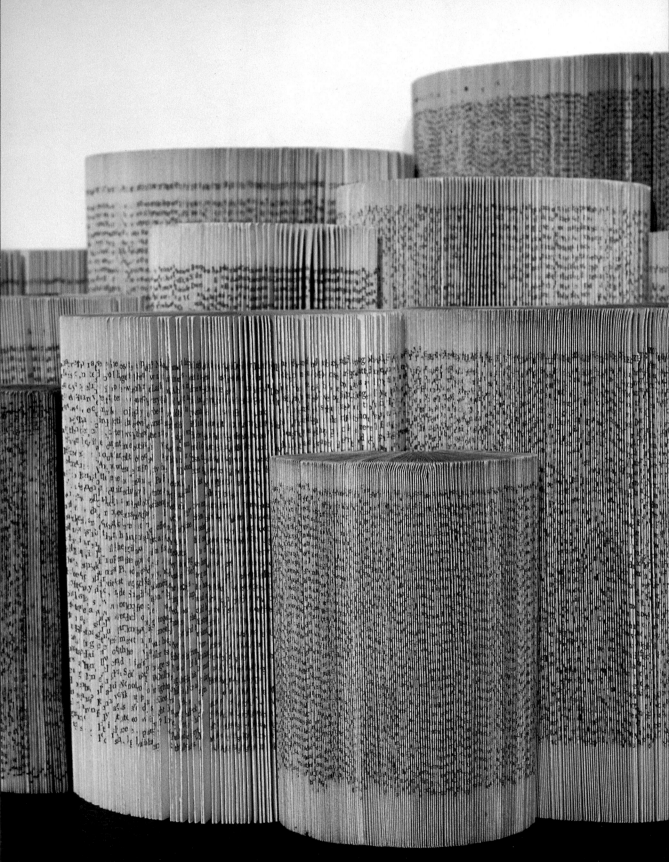

DOUG BEUBE

I (OPPOSITE)

City, 1990/2002. Altered books.

II

Masked Words, 2011 (shown with and without headpiece). Altered dictionary, wood, metal, marble.

DOUG BEUBE began altering the book's structure in 1979, pushing its physical properties by cutting, folding, gouging, piercing, and slashing. Ever since, Beube has excavated found books as if they were undiscovered archeological sites. The codex may be an outdated technology in a digital age, but it is the transformation from analog print to electronic type that inspires Beube to morph such antiquated recording devices of information and knowledge into visually meaningful objects. The viewer engages with the recontextualized object, which might otherwise have gone unnoticed in its customary setting, and participates in its transformation through a critique of, or dialogue with, the methods the artist uses to modify the bookwork.

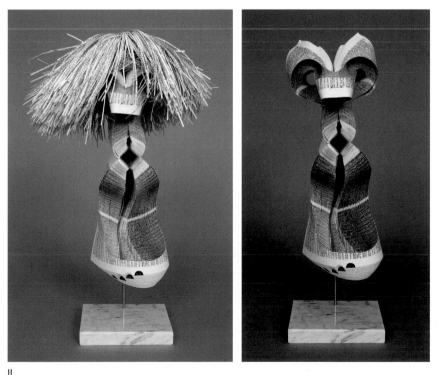

II

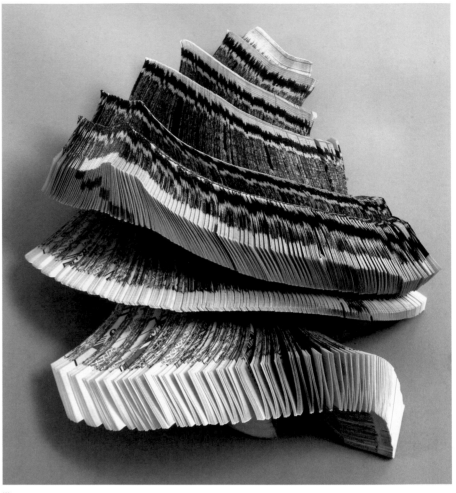

III

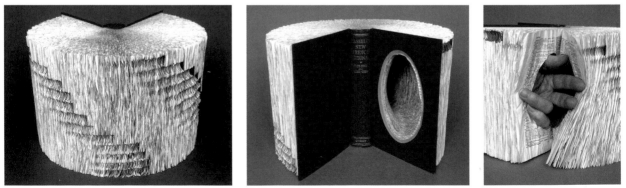

IV

III

Disaster: Twisters:
Twisted Borough, 2009.
Yellow phone book pages.

IV

Ruffled Collar, 2004.
Altered French to English
dictionary.

V

Vest of Knowledge, 2008.
Altered encyclopedia,
fabric, vinyl, wire,
metal, wax.

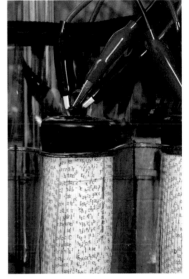

V

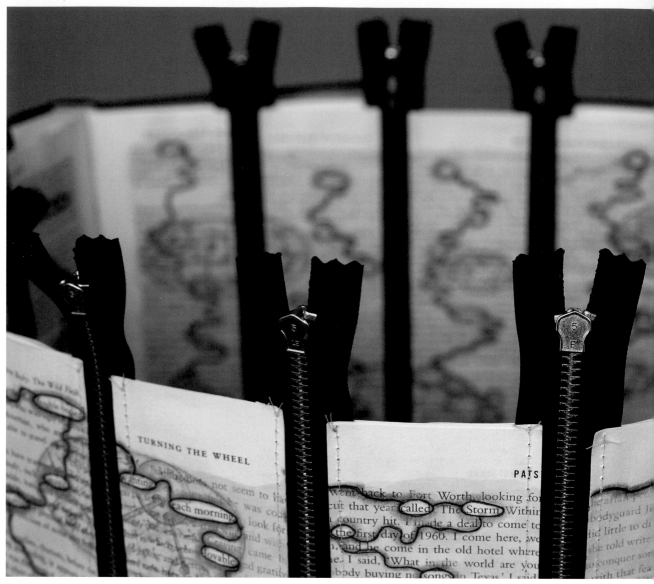

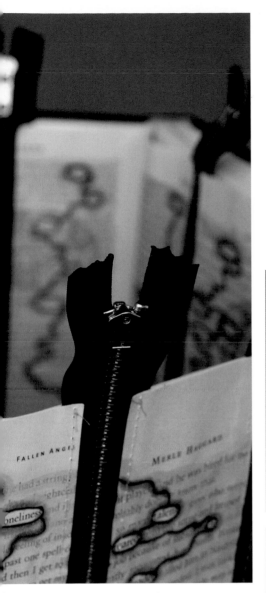

The Many Lives of Miss Chatelaine, 2008. Altered books, collage, sculpture, acrylic, ink, thread, paper, zippers.

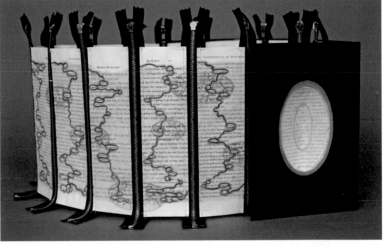

SU BLACKWELL

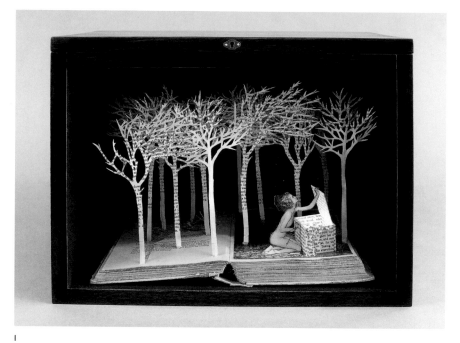

I

SU BLACKWELL finds inspiration for her enchanting book sculptures in the realm of fairy tales and folklore. Her tableaux tend to feature young girls who inhabit haunting, fragile settings that convey the vulnerability, anxiety, and wonder of childhood. There is a quiet melancholy in Blackwell's work, depicted in her choice of materials and subtle color. She reads each story first, and her final design is intimately tied to the tale. Her works are reminiscent of beloved children's pop-up books and make-believe worlds. For Blackwell, who has always loved the idea of escaping into a good story, books "can transport you to a different time and place, and somewhere more magical."

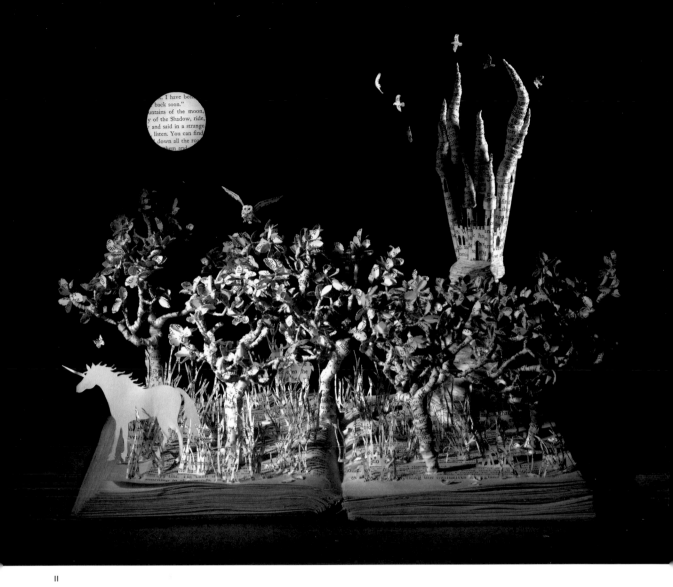

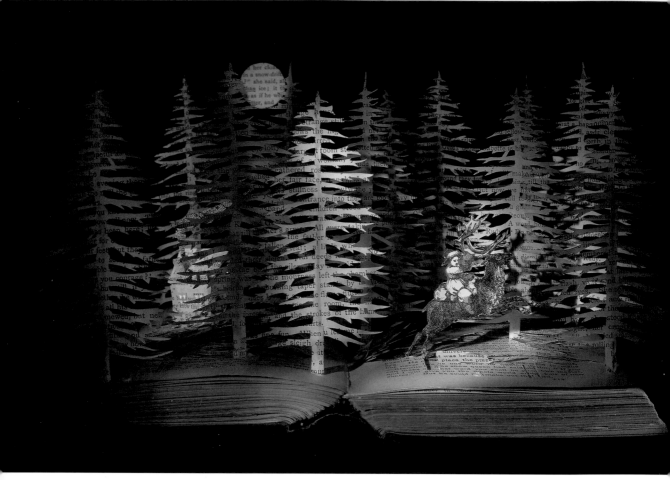

III

III

The Snow Queen, 2008.
Secondhand book, lights,
glass, wood box.

IV

Alice: A Mad Tea Party,
2007. Deconstructed
book in a box.

V

Red Riding Hood, 2010.
Secondhand book, lights,
glass, wood box.

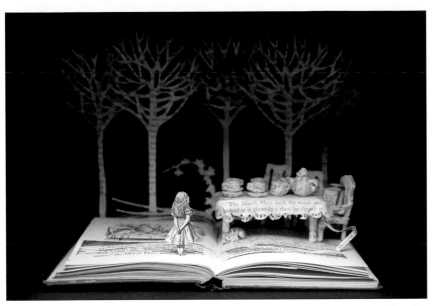

IV

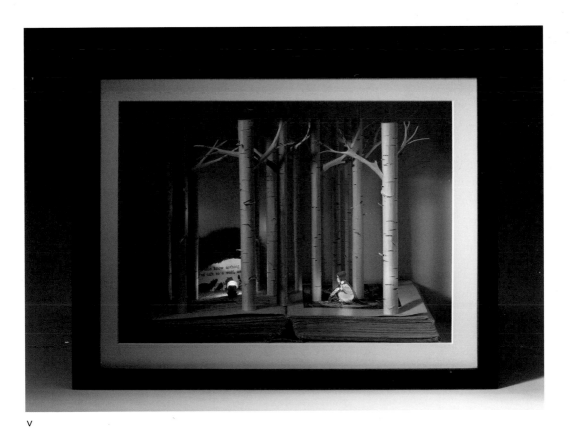

V

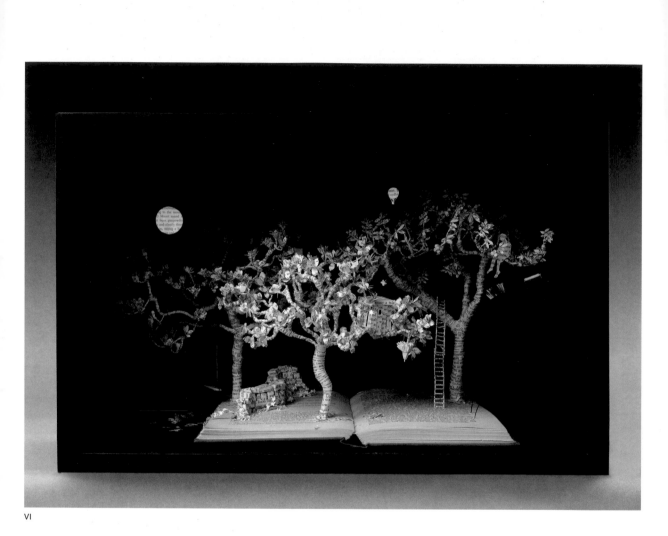

VI

VI, VII

The Baron in the Trees,
2011. Secondhand book,
lights, glass, wood box.

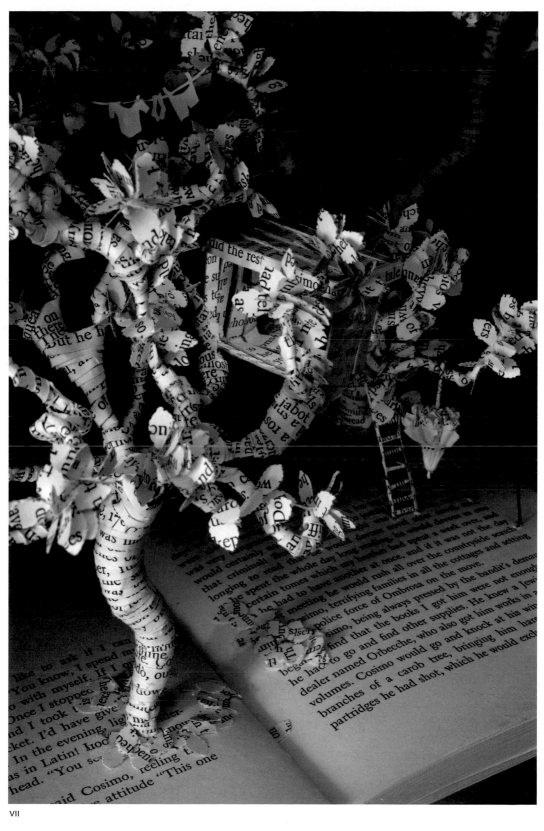

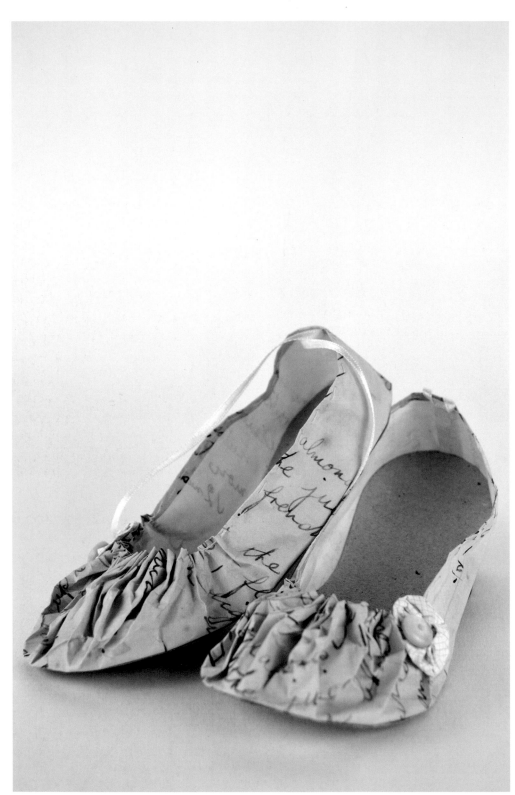

I

Cook Book Ballet Slippers,
2012. Vintage cookbook
pages, ribbons, buttons,
hand-stitching.

II

Curley Locks Gloves,
2011. Vintage nursery
rhyme book pages,
wax, buttons, machine
stitching.

III

*Ladybird Book Baby
Shoes*, 2012. Vintage
Ladybird book pages,
moulding medium,
machine stitching.

JENNIFER COLLIER

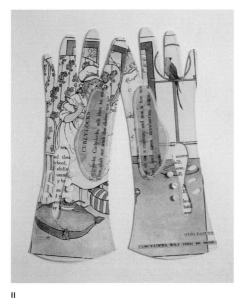

II

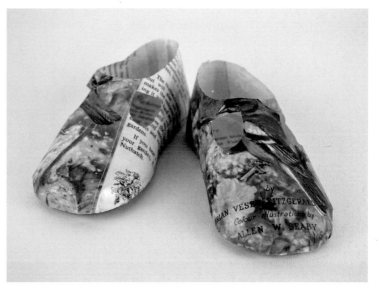

III

—

JENNIFER COLLIER's practice focuses on creating work from paper—pages from books such as nursery rhymes, cookbooks, and children's stories with delightful imagery. Scouring flea markets and charity shops, Collier finds source material and then explores ways to transform it, giving new life to things that otherwise would go unloved or be thrown away. Books serve as both inspiration and the media for her work, with the narrative on the pages suggesting the final form. With techniques of bonding, waxing, and trapping, Collier produces unusual "fabrics" that she then uses to remake everyday household objects. She treats the papers as if they were cloth, stitching with thread to create a contemporary twist on traditional textiles.

IV

Super 8 Camera,
2011. Vintage theater
programs, gray board,
machine stitching.

V

Paper Typewriter, 2011.
Vintage typewriter man-
ual pages, gray board,
machine stitching.

VI

Nursery Rhyme Knife Set,
2011. Vintage nursery
rhyme book pages,
wallpaper, gray board,
machine stitching.

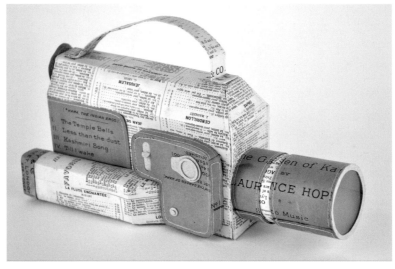

IV

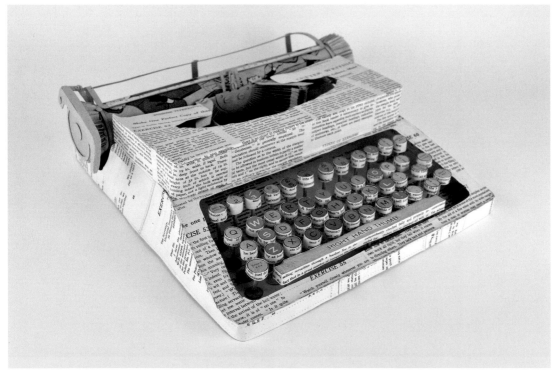

V

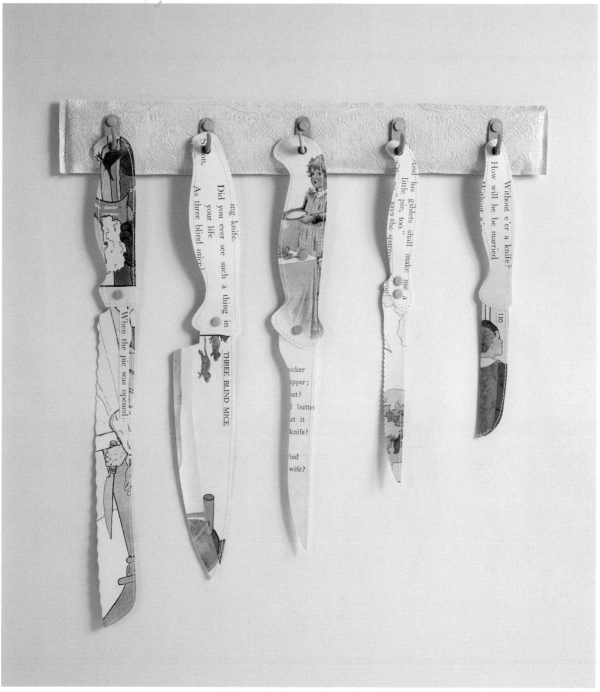

VI

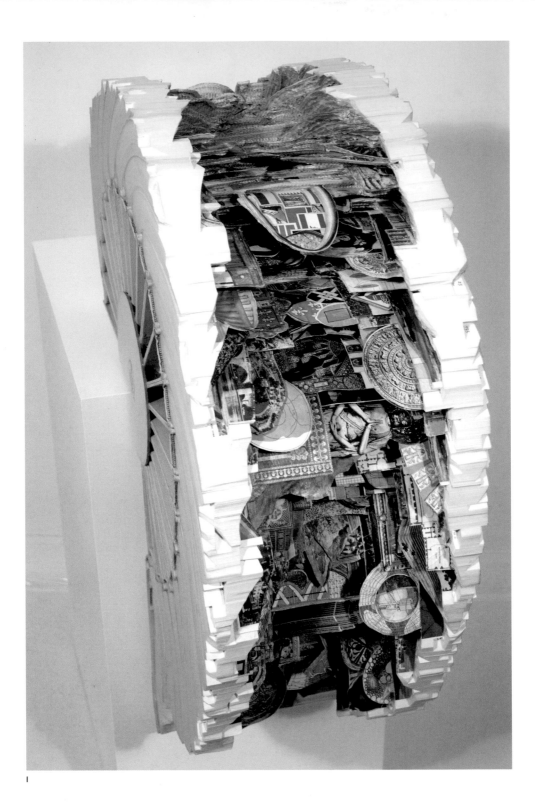

I

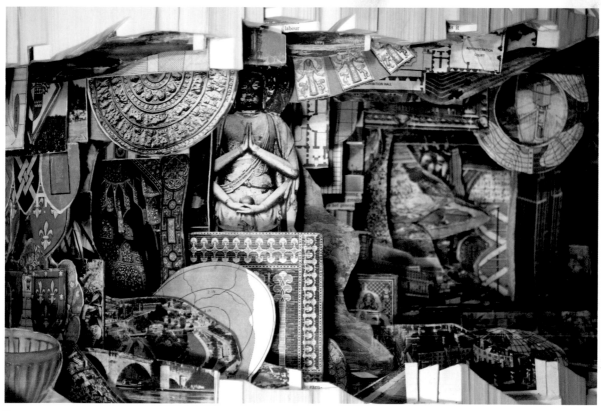

II

BRIAN DETTMER

I, II

Saturation Will Result,
2011. Encyclopedia set,
acrylic medium, pedestal.

Through meticulous excavation and concise alteration, **BRIAN DETTMER** edits traditional found books. He begins by sealing the edges, creating an enclosed vessel full of unearthed potential. He cuts into the surface of the book and dissects down, working with knives, tweezers, and surgical tools to carve one page at a time, exposing each layer while cutting around text and images of interest. Nothing inside the books is relocated or implanted, only removed. Images and ideas are revealed to expose alternate histories and memories. Dettmer considers his work a collaboration with the existing material and its past creators, and the completed pieces reveal a medium transformed, the content recontextualized, while new meanings or interpretations emerge.

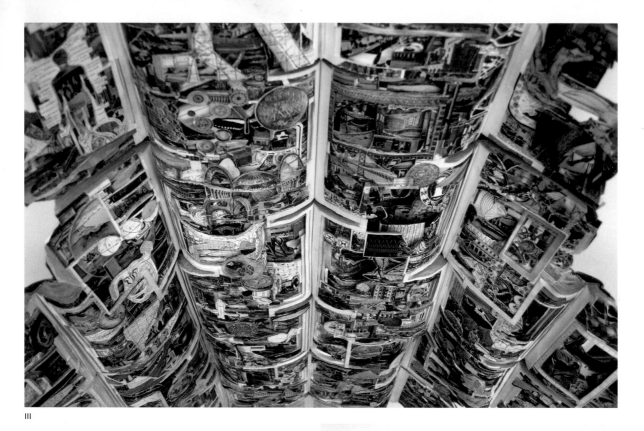

III

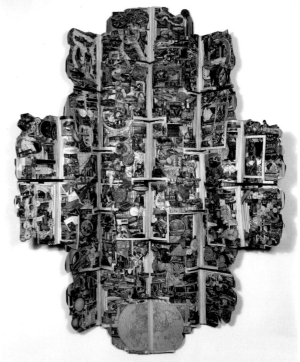

IV

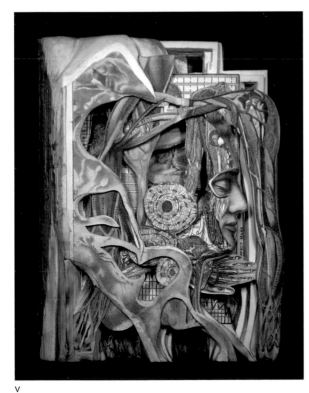

V

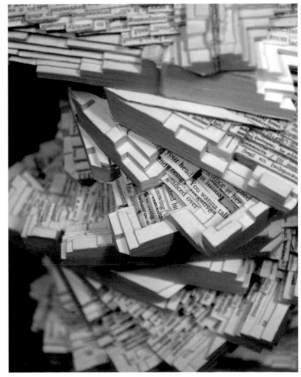

VI

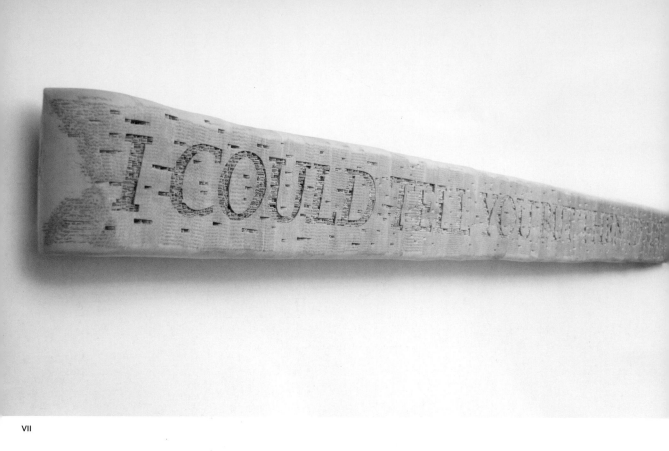

VII

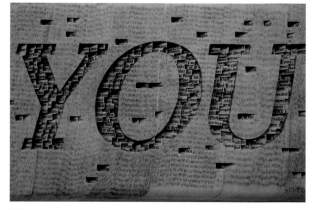

VIII

———

VII, VIII

I Could Tell You, 2011. Paperback
books, acrylic medium.

IX

The March of Democracy, 2010.
Hardcover books, acrylic medium.

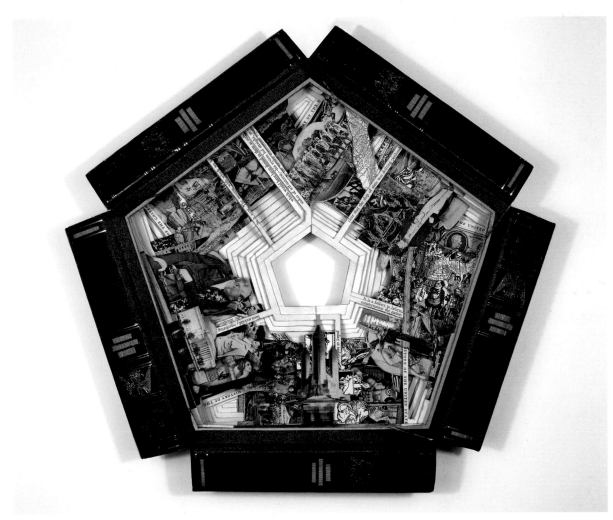

IX

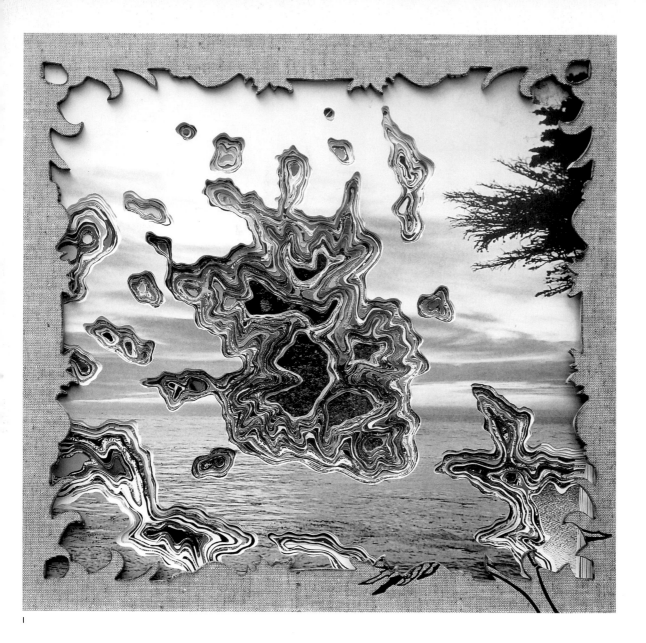

I

I

El insólito paisaje mexicano, 2011.
Trimmed book (laser and hand).

II

Semillas de libro (Seed Book), 2012
(detail). Trimmed book (laser and
hand).

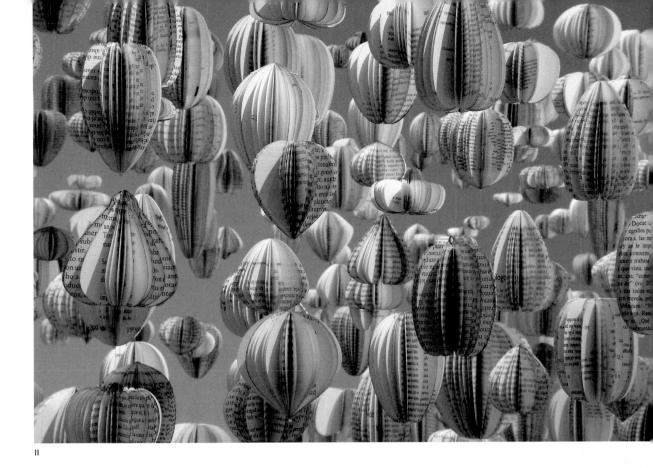

II

ARIÁN DYLAN

———

Most of **ARIÁN DYLAN**'s creative process is based on the discursive nature of books. His carved books, or *Cavidades* (cavities), combine visual and verbal language, and play upon the images and text within. With a precision blade Dylan cuts into covers and pages, creating intricate, thought-provoking, and often witty imagery that is apropos of the book's subject matter. For Dylan, the book is a vehicle to other worlds with an enigmatic power to free the reader from a more insular place. Subtracting from the book allows him to interpret its content and propose new meaning, and in the carving out he creates a space for ideas to inhabit.

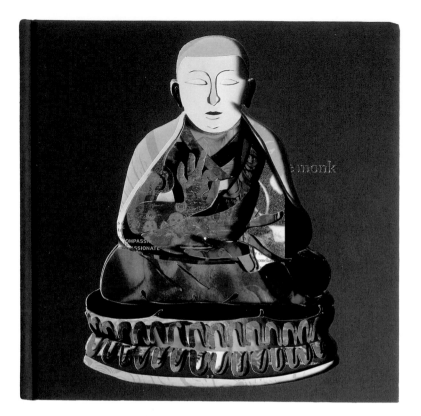

III

IV

V

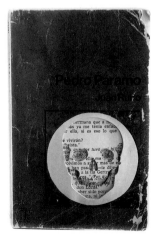

VI

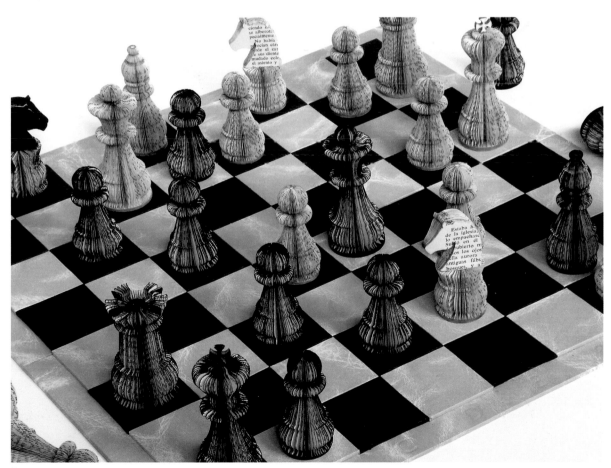

VII

YVETTE HAWKINS

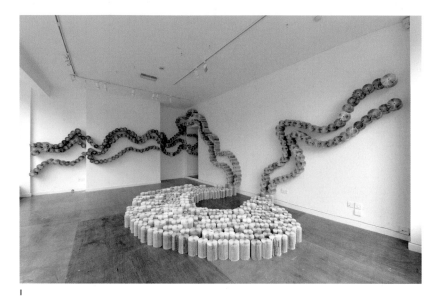

I

I, II

No Land In Particular, 2010. Installation at the Globe Hub, United Kingdom, 2010.

YVETTE HAWKINS makes tactile, engaging, and textural sculptures and installations that explore suggestion and secrecy. Her practice is concerned with the physical acts of looking, reading, and listening, and books and printed ephemera lend perfectly to this end. Hawkins works in intricate detail on a large scale. She folds, cuts, prints, and stitches hundreds of times over, employing traditional craft techniques to create elaborate installations that fill whole rooms, span ceiling to floor, and offer spaces for viewers to walk through. The result: a world interwoven with literary and physical illusion. Her sculptures encourage viewers to be consciously aware of their surroundings by controlling and manipulating the way things can be seen, read, and heard.

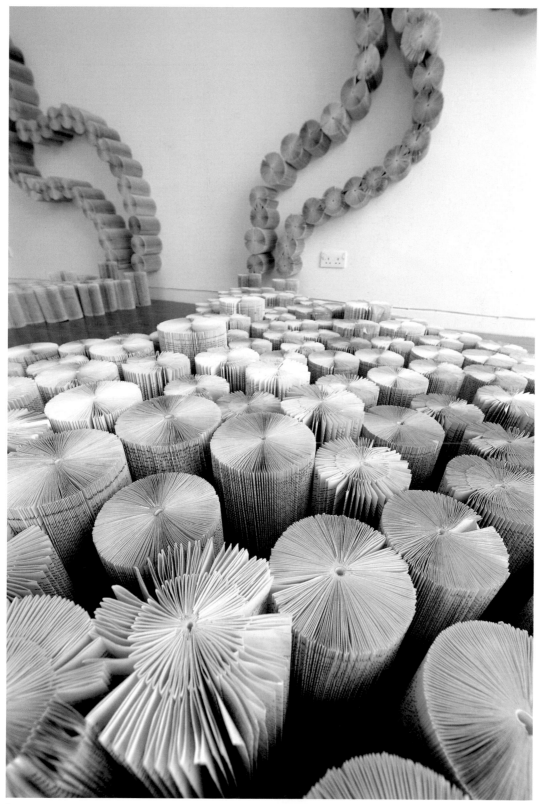

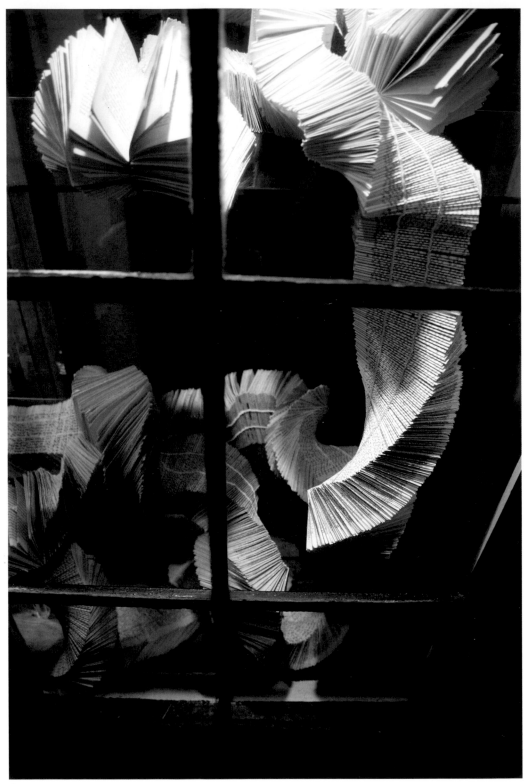

III

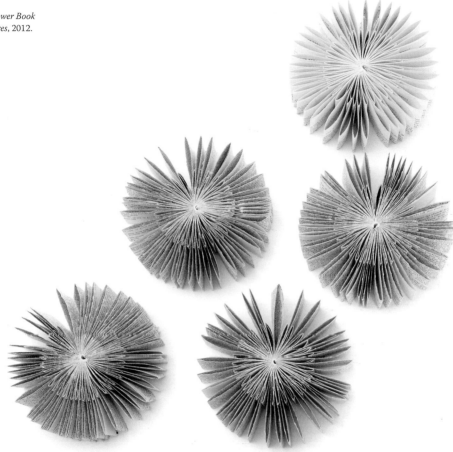

IV

V, VII

Nothing to Read Here,
2010. Installation at Keel
Row Shopping Centre,
United Kingdom, 2010.

VI

*All the Books I Have
Never Finished,* 2010
(detail, studio view).

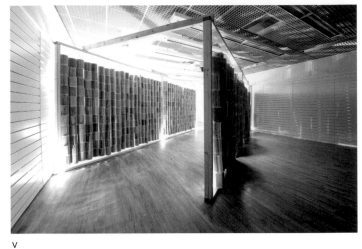

V

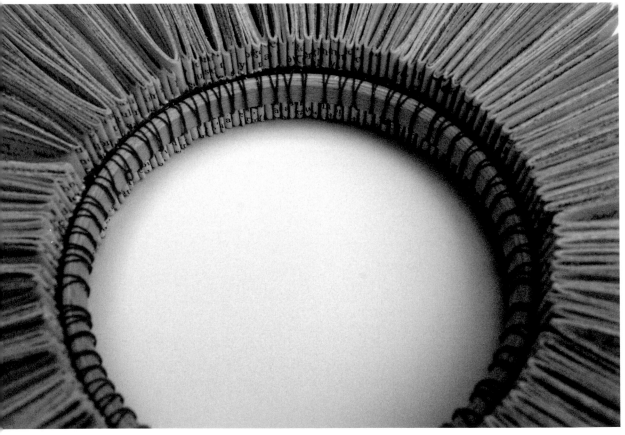

VI

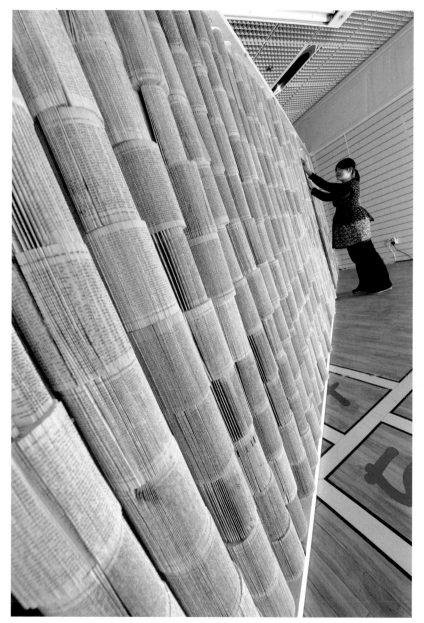

VII

Obsolete textbooks, tattered pulp fictions, and disused dictionaries are a source of creative inspiration for sculptor **NICHOLAS JONES**. In most cultures, books are revered as repositories of stories, factual information, and images. Jones's use of books as the basis of his art shifts our "reading" of these familiar objects to a sculptural idiom appreciated for its physical shape and allusion. As the raison d'être of the book has been altered and all functionality lost, the viewer is able to engage with the inherent "bookness" of the book. Cutting, tearing, sewing, and folding the leaves of each book radically alter the manner in which we engage with these volumes.

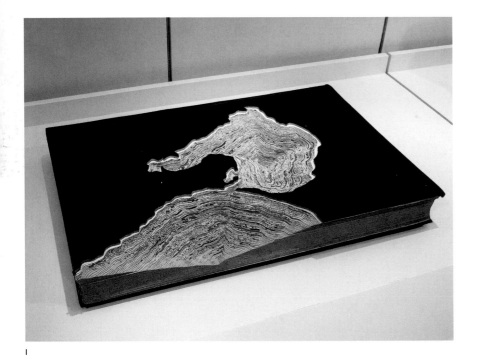

I

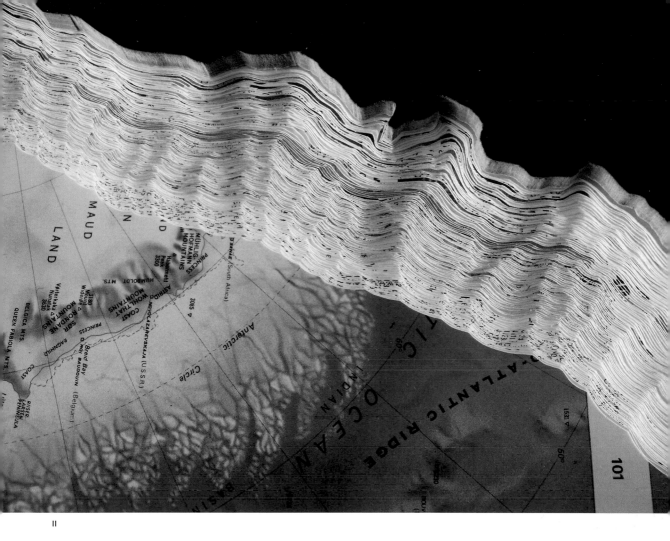

II

NICHOLAS JONES

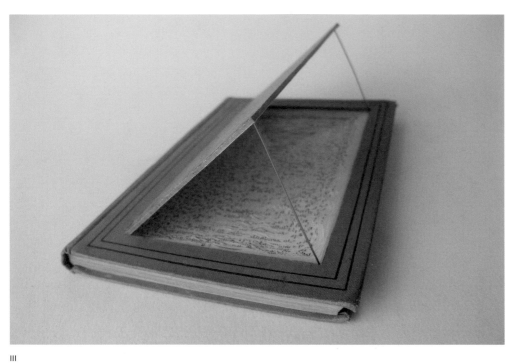

III

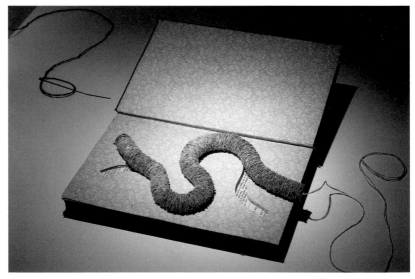

IV

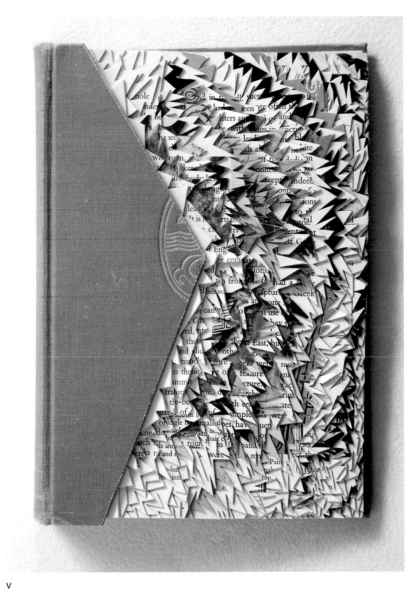

III

The Barber of Seville,
2008. Cut book with
steel pins.

IV

Bookworm Ensconced,
2008. Cut book with
bookworm made from
torn and sewn paper on
linen thread.

V

Greek Art, 2007.
Cut book.

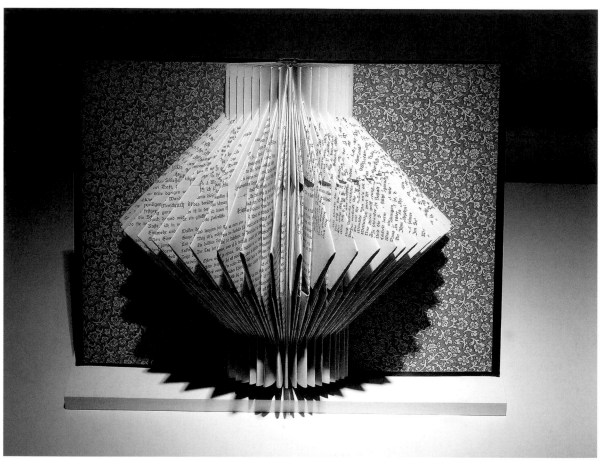

VI

VI

Gedichte, 2008.
Folded book.

VII

*Australian Year Book
1969*, 2010. Cut book.

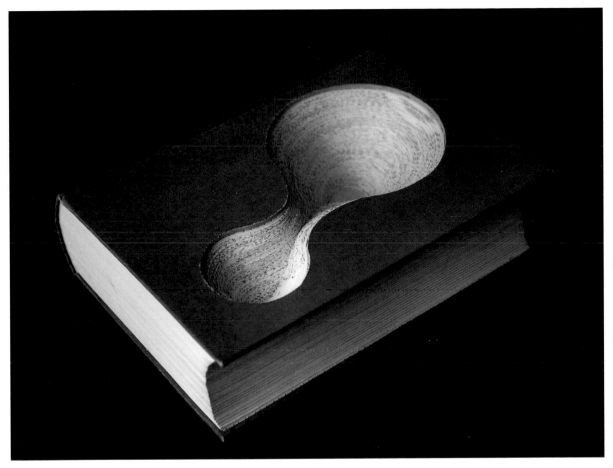

VII

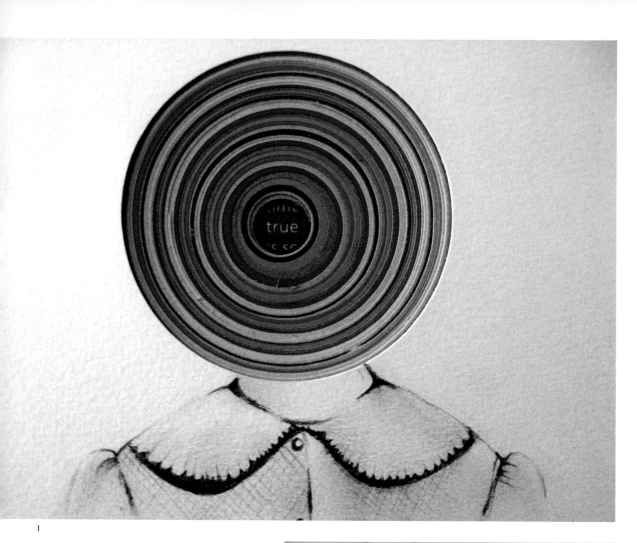

I

II

JENNIFER KHOSHBIN

JENNIFER KHOSHBIN's creations have an illustrative feel. Using books as her canvas, Khoshbin creates a new narrative beyond what the text first intended. She explores the idea of story, fable, and tale within a modern aesthetic through images that include children, astronomy, botany, and animals. She designs her works in a way that allows onlookers to realize the book's meaning from a different point of view. Since the encounter with text has now become mostly an online experience, Khoshbin is reimagining the future of the book itself. Tales come to life in her extensive labor of paper cuttings, drawings, and sculptures.

I

True, 2009. Paper, graphite.

II

June 1974, 2008. Cut book, paper, graphite.

III

Look, 2009. Cut book.

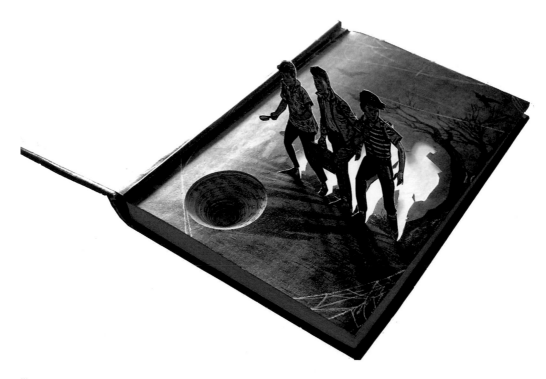

III

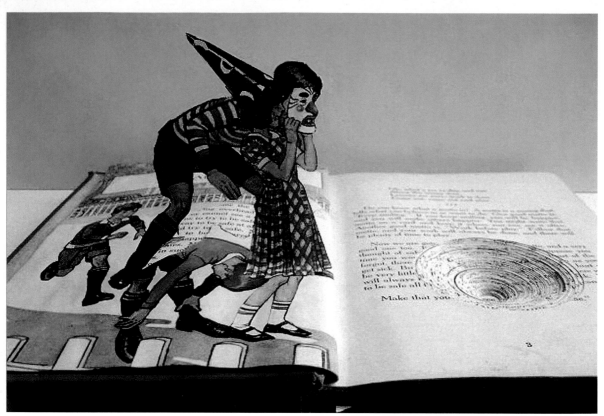

IV

IV

Masked Leap, 2009. Cut book.

V

Swinging My Way Back, 2009.
Cut book.

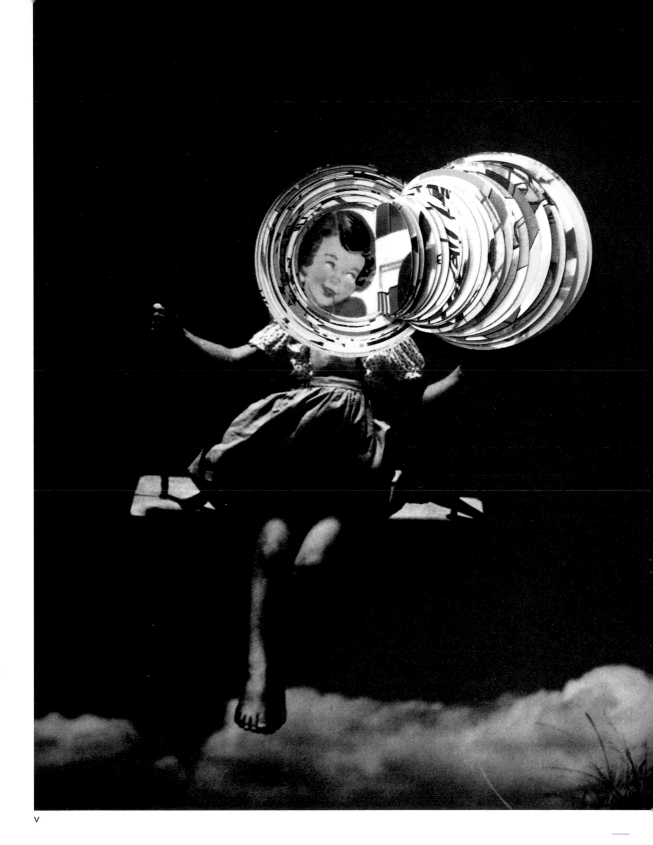

v

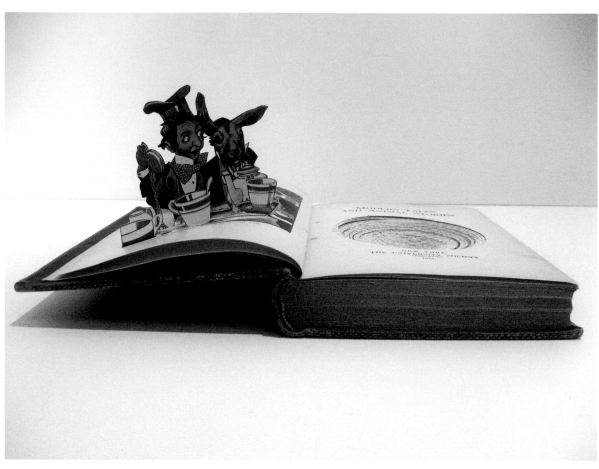

VI

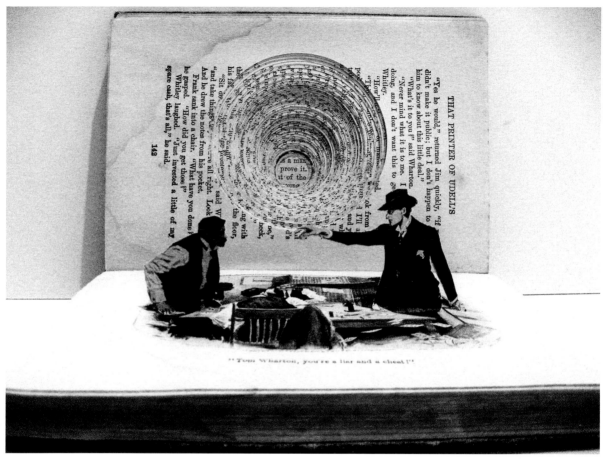

VII

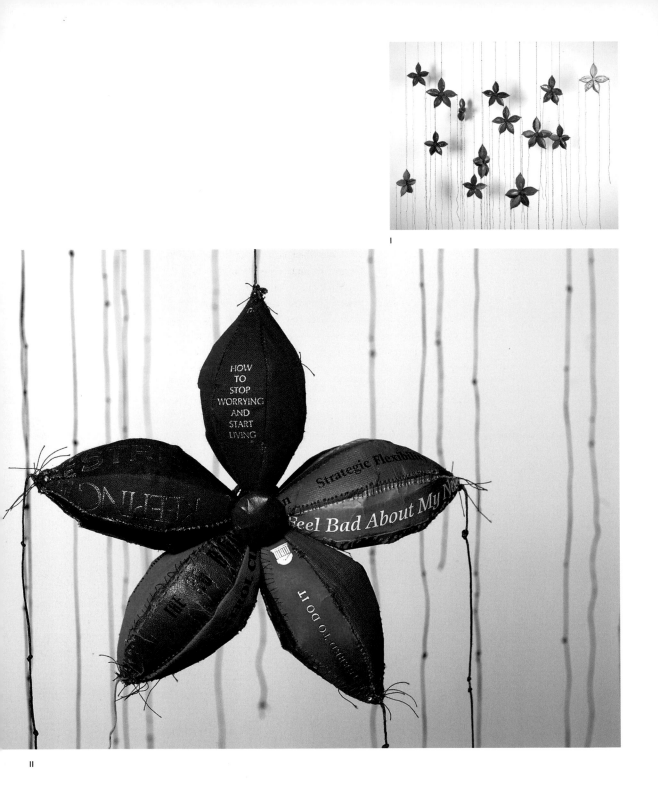

I

II

LISA KOKIN

LISA KOKIN grew up in a home where books were treated as reverential objects, so it was with much trepidation that she took her X-Acto knife to a book over twenty years ago. The first cut was the hardest, but since then she has been happily reassembling, chopping, shredding, pulping, de-spining, and otherwise eviscerating books that she rescues from the landfill. Humor and a critique of the status quo are hallmarks of Kokin's work. Most recently she has turned her attention to self-help books in need of transformation; using mostly the spines and added thread, she reconfigures them into deceptively cheerful pieces, which only upon closer inspection reveal their more introspective source.

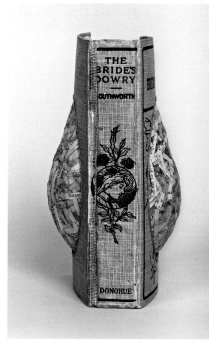

III

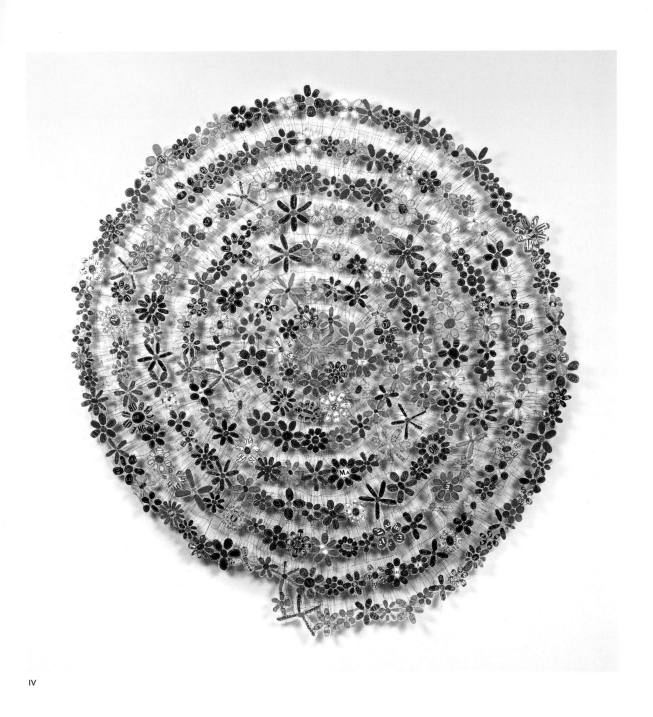

IV

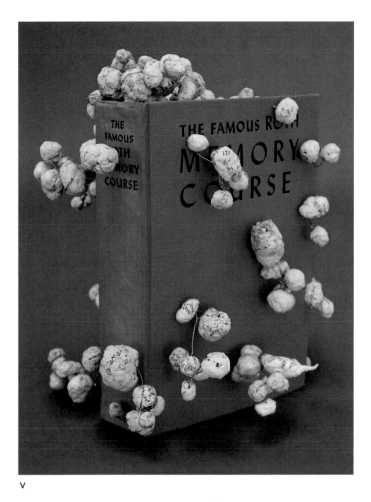

V

IV

Panacea Plus, 2010. Self-help book spines, PVA glue, mull, thread.

V

The Famous Roth Memory Course, 2007. Pulped and reassembled book pages, PVA glue, wire.

VI

Four Balls Short, 2008. Shredded and reassembled world atlas pages, PVA glue, wire.

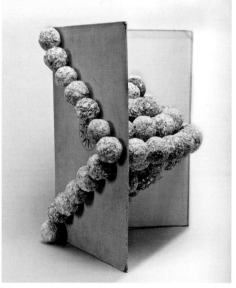

VI

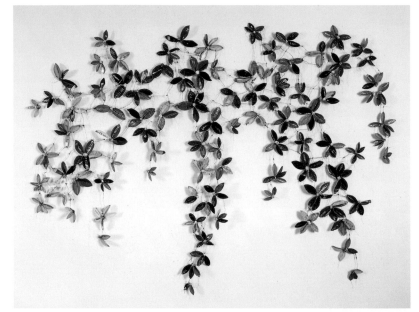

VII

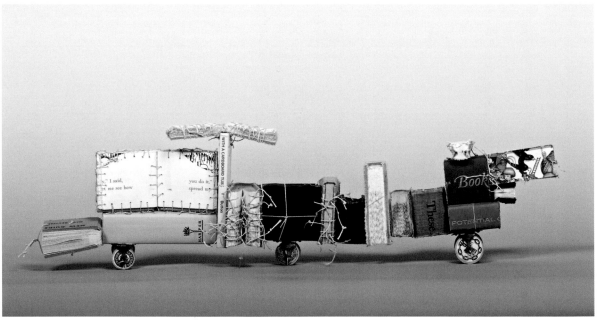

VIII

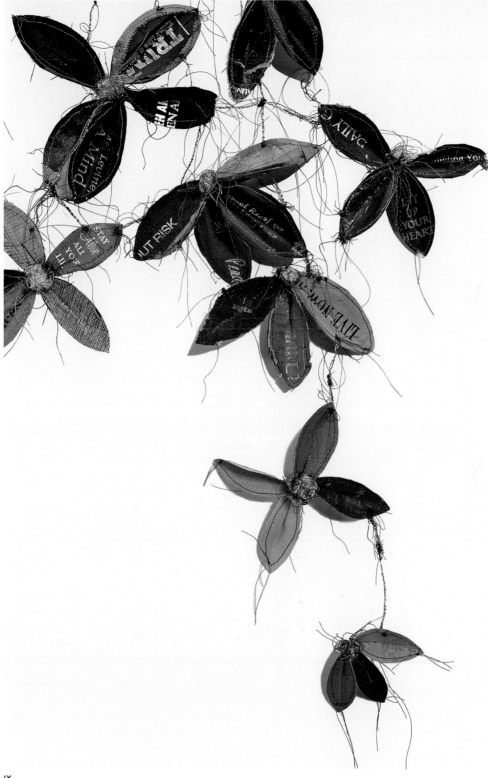

VII

How to Be, 2010. Self-help book spines, PVA glue, wire, mull, thread.

VIII

Me See How You Do It, 2009. Book fragments, waxed linen, wooden spools, metal hinges.

IX

How to Be, 2010 (detail). Self-help book spines, PVA glue, wire, mull, thread.

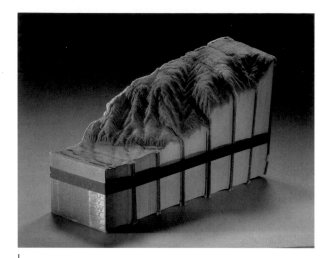

I

GUY LARAMÉE

I, II

El amor por las Montaña nos cura, 2012. Carved Litré dictionary, inks, ribbon, little book cutout.

For **GUY LARAMÉE**, the erosion of cultures, and of culture as a whole, is a theme he has woven through his practice since 1983. Moved by what he sees as the diminishing state of books and libraries, Laramée originates his work from the idea that ultimate knowledge could be an erosion instead of an accumulation. He carves landscapes out of books, and the mountains of disused knowledge metamorphose to mountains, hills, and fields of another kind, places that apparently do not say anything, places that simply are. Laramée's intent is that these scenes will challenge everything we know and everything we think we are.

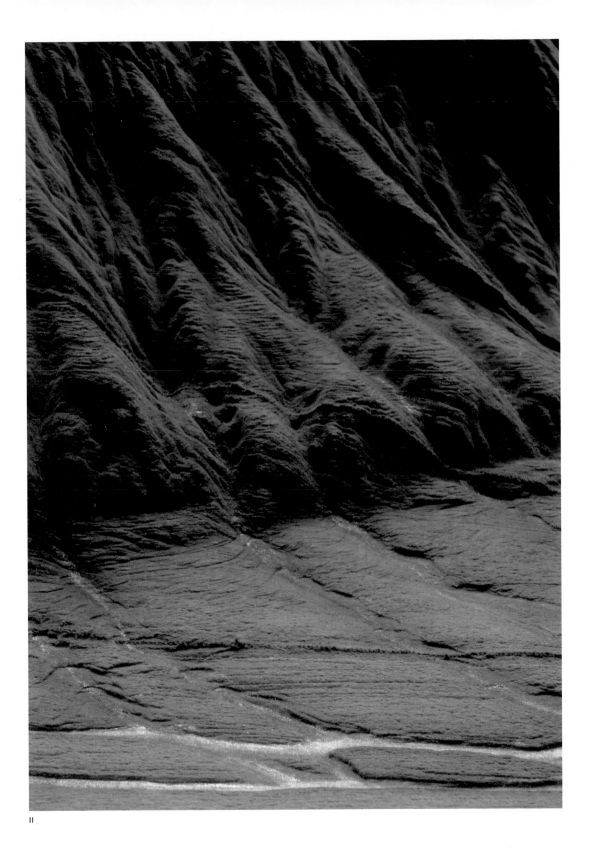

II

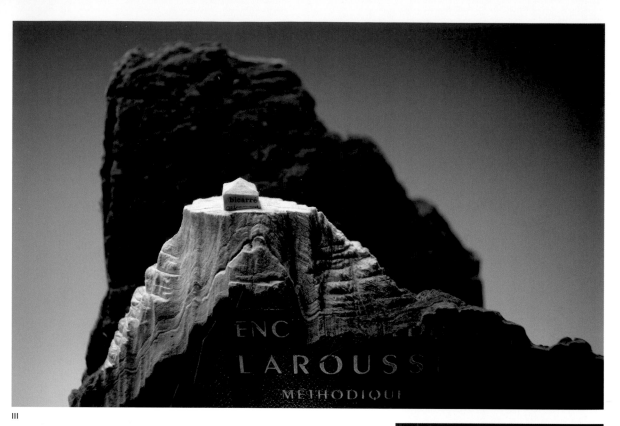

III

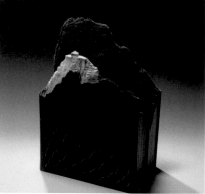

IV

III, IV

Larousse méthodique, 2011. Carved
Larousse dictionary, inks, bitumen
of Judea.

V

The Web, 2012. Carved dictionary
(*Webster's Encyclopedic Unabridged
Dictionary of the English Language*),
inks, paint (covers), copper holder,
bitumen of Judea.

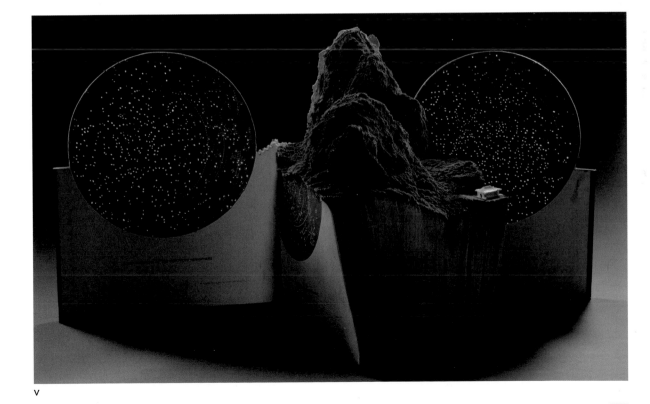

V

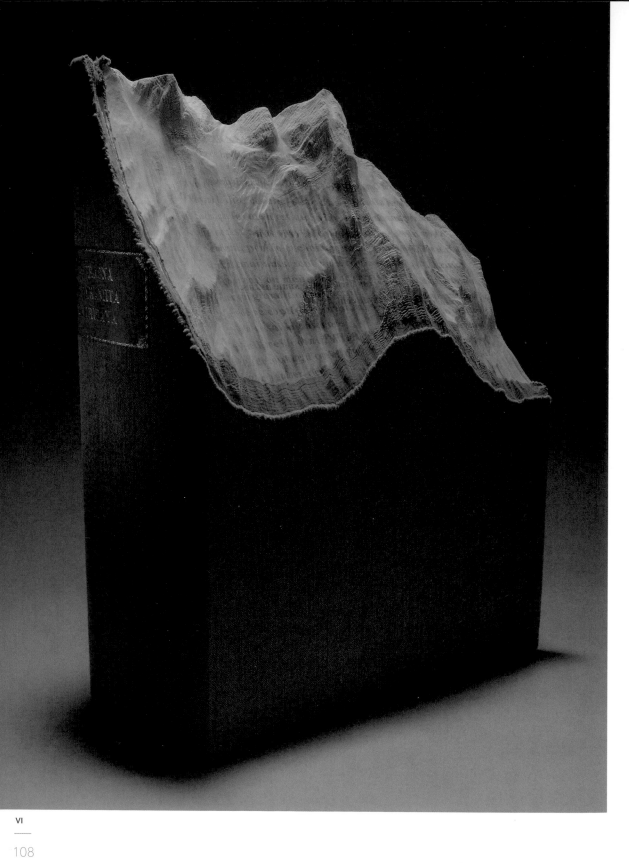

VI

Prajna Paramita, 2011.
Carved artist book (1,000
copies of a Buddhist
Sutra, bound by the
master binder Clément
Poirier, covered with
linen and embossed
with gold).

VII

Stupa, 2012. Carved
Tibetan-Chinese
dictionary.

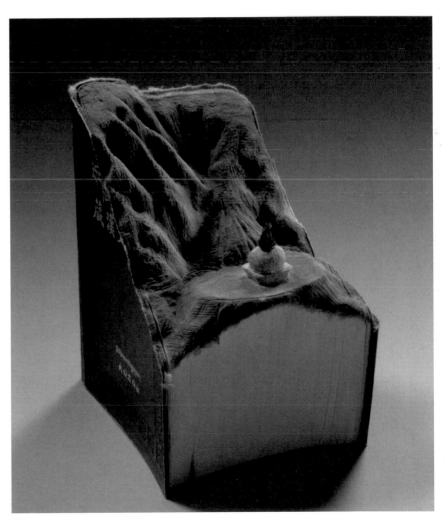

VII

PABLO LEHMANN

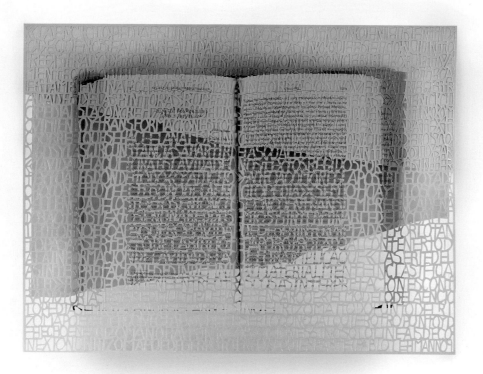

I

I

Reading and Interpretation VIII,
2009. Photographic print cut
out with text from *The Concept
of "text"* by Pablo Lehmann over
The Garden of Forking Paths by
Jorge Luis Borges.

II

Cut-out screen 1, 2006 (detail).
Canson paper printed with an
excerpt from *Signature Event
Context* by Jacques Derrida
and cut out with text from the
same title.

By transcribing text and cutting pages, **PABLO LEHMANN**
reconstructs books to create mesmerizing forms that often
resemble nets, lace, or labyrinthine webs of words. For
Lehmann, cutting papers is a way of writing, of creating
spaces, and of transfiguring texts into single objects. Each
page, each disjointed book, enables him to argue a personal
point of view; above all, it is a place where the reader is com-
mitted to inventing new paths of comprehension from each
cut text. In this sense, words are not just vehicles of meaning
but also shapes; they are mysterious webs that everyone can
interpret and read, using their most intimate codes and their
most secret desires.

un código, pero prefiero no c

de una cierta identidad de este elemento

usmo. A través de las variaciones

es preciso poder reconocer la identidad

qué es esta identidad paradójicamente la división o la disociación consis

n grafema? Esta unidad de la forma significante no se constituye sin

epetida en la ausencia no solamente de su «referente», lo cual es evid

uminado o de la intención de significación actual, como de toda

ilidad estructural de ser separado del referente o del significado (por

parece que hace de toda marca, aunque sea oral, un grafema en gener

ia no-presente de una marca diferencial separada de su pretendida «

incluso a toda «experiencia» en general si aceptamos que no hay exp

marcas diferenciales.

URA, QUE QUIZÁ NO EXISTE

un poco en este punto y volvamos sobre esta ausencia de refer

to de la intención de significación correlativa. La ausencia del r

hoy día. Esta posibilidad no es sólo una eventualidad emp

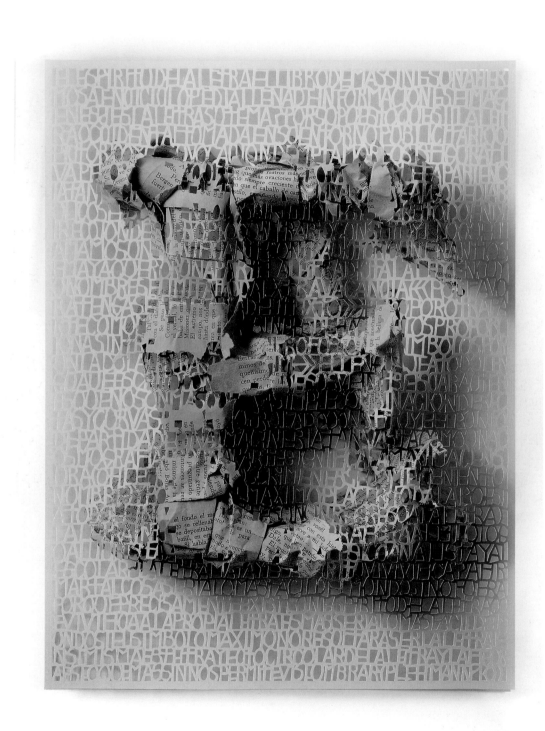

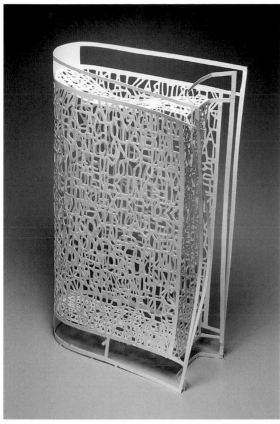

IV

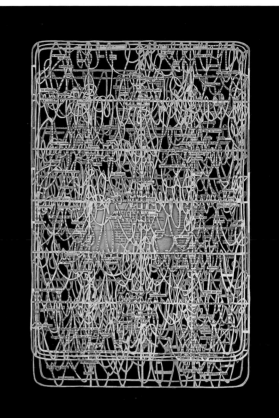

V

III

Baroque Vowel (E), 2010.
Photographic print of book frag-
ments, cut out with text from
Variations on Writing by Roland
Barthes.

IV

Naked Book, 2007. Paper cut
out with text from *Variations on
Writing* by Roland Barthes.

V

Incompossible Text 1, 2006. Cut-
out pages from *Edipo* and *Limits*
by Jorge Luis Borges and *Don
Quijote de la Mancha* by Miguel
de Cervantes.

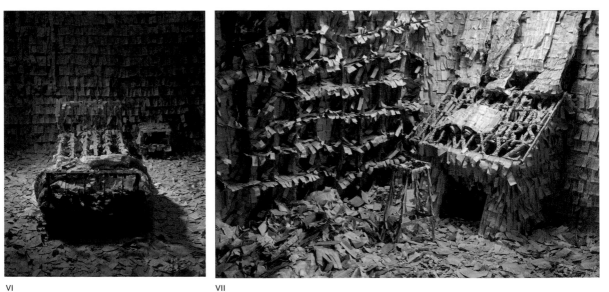

VI VII

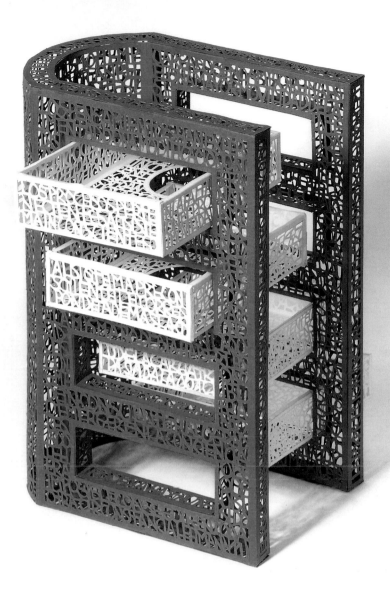

VIII

JEREMY MAY

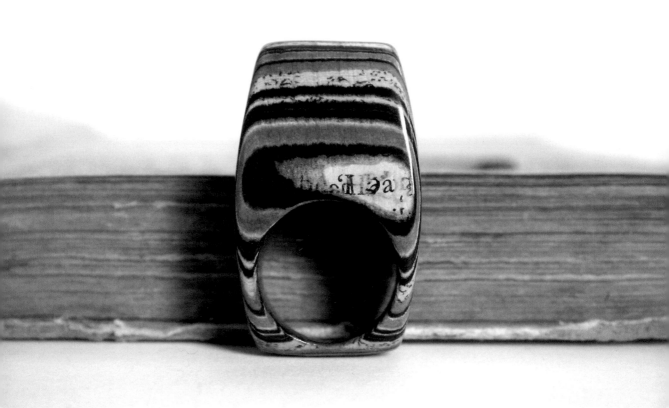

JEREMY MAY transforms books into jewelry, or wearable "narratives," of exquisite beauty. His process is methodical: after reading the book, he selects a distinctive quote that inspires the design of the piece; he then removes a selection of pages, laminating with additional recycled colored paper and then polishing them to a high gloss. Text and image extend through the object but are only exposed at the surfaces, affording a tantalizing glimpse of the narrative within. When not worn, the jewel nests in the book's excavated space, returned to its original context. Each piece is one of a kind and carries a serial number.

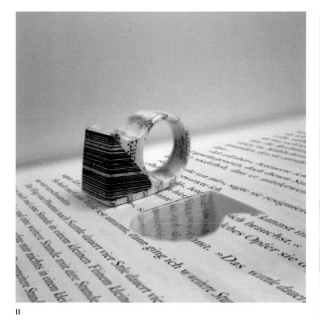

II

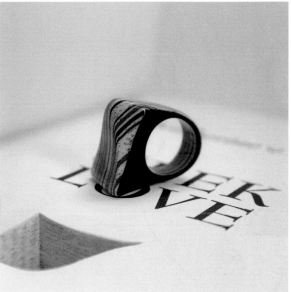

III

I

Serial no. 070—Les Étapes de Madeleine, 2009. Book pages with green, brown, and dark red paper. (*Les Étapes de Madeleine* by Joséphine Colomb)

"Levait les yeux au ciel et joignait les mains pour une prière d'actions de grâces."

II

Serial no. 172—Bis(s) zum Morgengrauen, 2011. Book pages with red, brown, green, and gray paper. (*Twilight* by Stephenie Meyer)

"I like the night. Without the dark, we'd never see the stars."

III

Serial no. 136—Geek Love, 2011. Book pages with dark green, burgundy, and blue paper. (*Geek Love* by Katherine Dunn)

"It may be that the impressions of her infancy are caught somehow in the pulp of her eyes, luring her. Or there may be some hooked structure in her cells that twists her toward all that the world calls freakish."

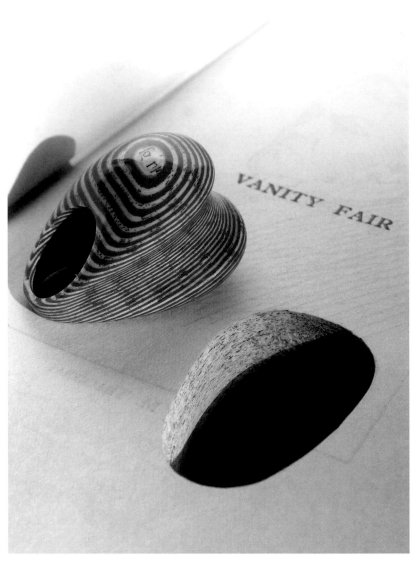

IV

IV

Serial no. 028—Vanity Fair, 2009. Book pages with orange paper. (*Vanity Fair* by William Makepeace Thackeray)

"But the truth is, neither beauty nor fashion could conquer him. Our honest friend had but one idea of a woman in his head."

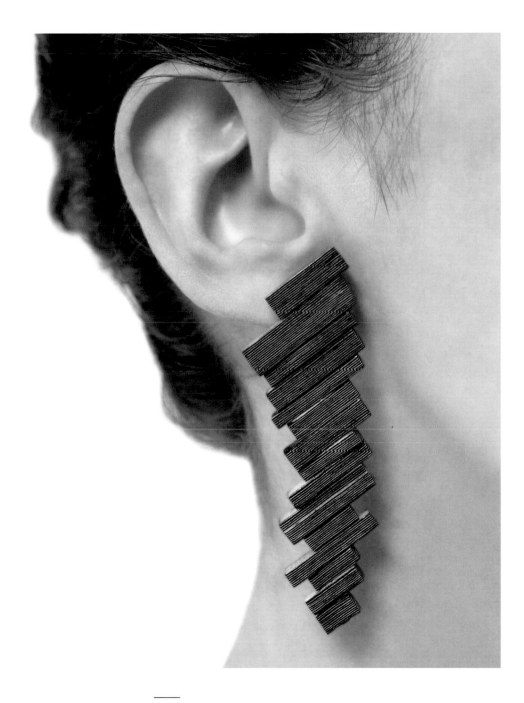

∨

Serial no. 141—Flowers, 2011. Book pages with black and dark blue paper. (*Flowers* by Janet Harvey Kelman, C. E. Smith)

"When the flowers are withered they are followed by groups of beautiful dark red berries."

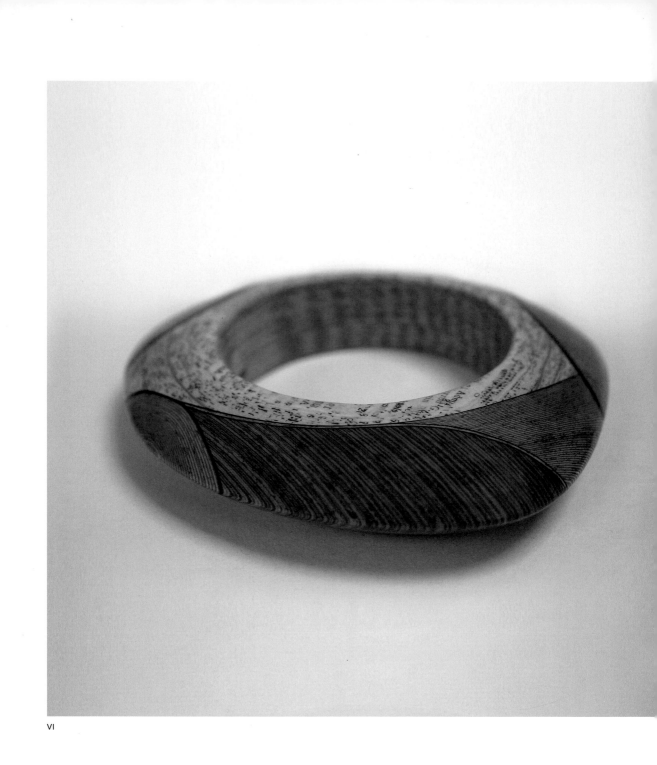

VI

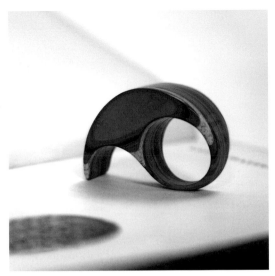

VII

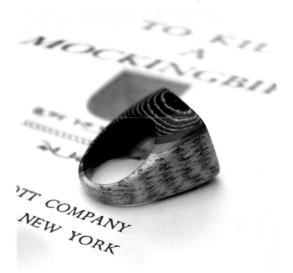

VIII

Serial no. 205—The Everglades, River of Grass, 2011. Book pages with blue, green, light brown, and dark gray paper. (*The Everglades: River of Grass* by Marjory Stoneman Douglas)

"The miracle of light pours over the green and brown expanse of saw grass and of water, shining and slowly moving, the grass and water that is the meaning and the central fact of the Everglades. It is a river of grass."

VII

Serial no. 140—Lady Chatterley's Lover, 2011. Book pages with red, pink, dark blue, and black paper. (*Lady Chatterley's Lover* by D. H. Lawrence)

"All the lower wood was in shadow, almost darkness. Yet the sky overhead was crystal. But it shed hardly any light. He came through the lower shadow towards her, his face lifted like a pale blotch."

VIII

Serial no. 161/1—To Kill a Mockingbird, 2011. Book pages with red, green, and dark blue paper. (*To Kill a Mockingbird* by Harper Lee)

"I'd rather you shoot at tin cans in the backyard, but I know you'll go after birds. Shoot all the bluejays you want, if you can hit 'em, but remember it's a sin to kill a mockingbird."

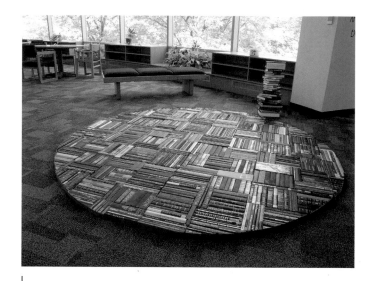

I

PAMELA PAULSRUD

The tactile, resonant, and communicative qualities that books offer in their traditional role are the same qualities that attract **PAMELA PAULSRUD** to use books in her sculptural work. Inspired by nature, language, dreams, and those quiet spaces, Paulsrud finds the book the perfect source with which to explore a new language, a new perspective, and a new way to tell a story. As with books, where the message and story hidden within only unfold when one takes the quiet time, space, and attention to be with it, Paulsrud's sculptural works offer a new and enchanting relationship between the viewer, the artist, and the object.

II

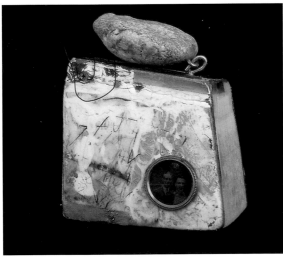

III

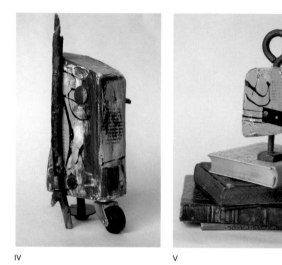

IV

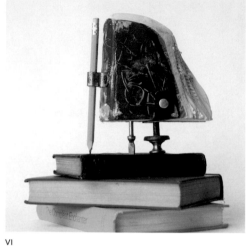

V

VI

IV

Elaborate Scheme, from the series *Dream Palimpsest*, 2009. Altered book, acrylic, plaster, Sumi ink, Xerox transfers, stick, stones, hardware, encaustic.

V

AWP, from the series *Dream Palimpsest*, 2009. Altered book, acrylic, plaster, Sumi ink, Xerox transfers, hardware, encaustic.

VI, VII

The Compleat Enchanter, from the series *Dream Palimpsest*, 2009. Altered book, acrylic, Sumi ink, Xerox transfers, hardware, pencil, encaustic.

SUSAN PORTEOUS

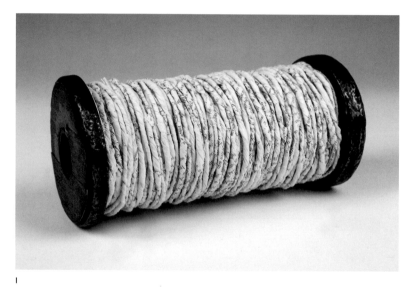

I

I

The Essential Gandhi, from the series *Gandhi,* 2012. Altered book, antique spool.

II, III

Bridge Complete, from the series *How to Play Bridge,* 2007. Altered book, linen, rocks.

SUSAN PORTEOUS uses found books as both subject matter and raw material in her work. Through cutting, tearing, folding, and rebinding, she creates a relationship between the content of the original book and the structure of the new form, and in the process adds layers of meaning and complexity. Although Porteous utilizes traditional binding techniques in many of her works, she exaggerates and manipulates the shapes, proportions, and materials so that the books become sensual objects no longer meant to be read from cover to cover, instead seen as an immediate and cohesive whole.

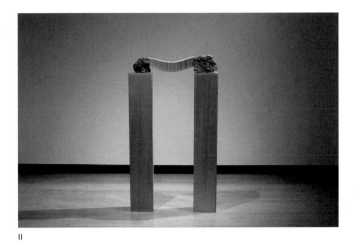

II

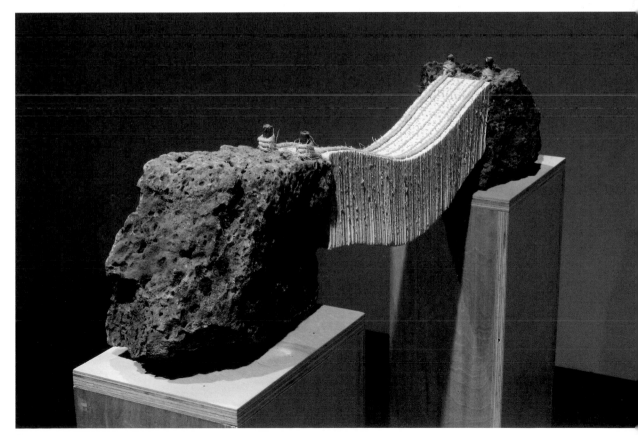

III

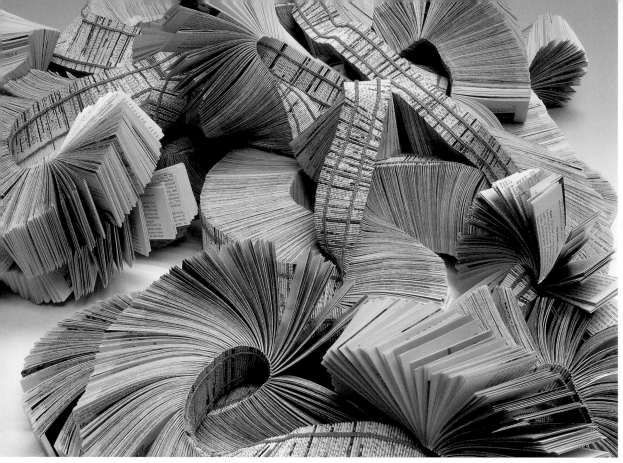

IV

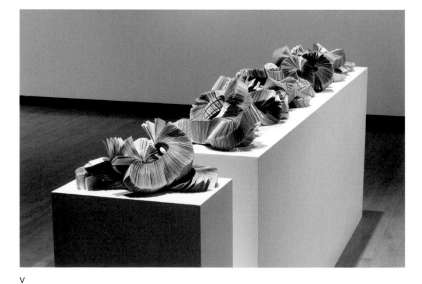

V

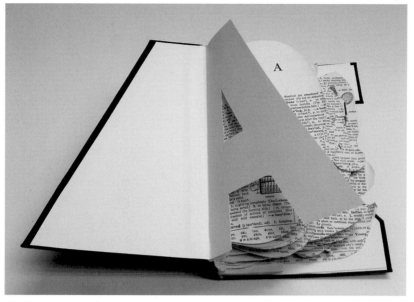

VI

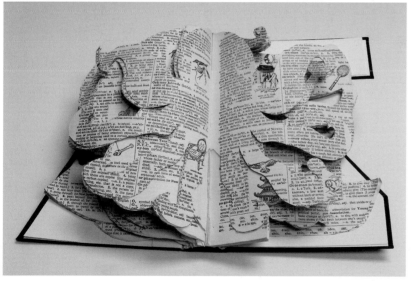

VII

IV, V

Encyclopedic, 2008. Altered books and linen. (*The World Book Encyclopedia,* complete set including reference book bound separately)

VI, VII

A to Z, 2007. Altered book (*An Illustrated Dictionary,* publisher unknown)

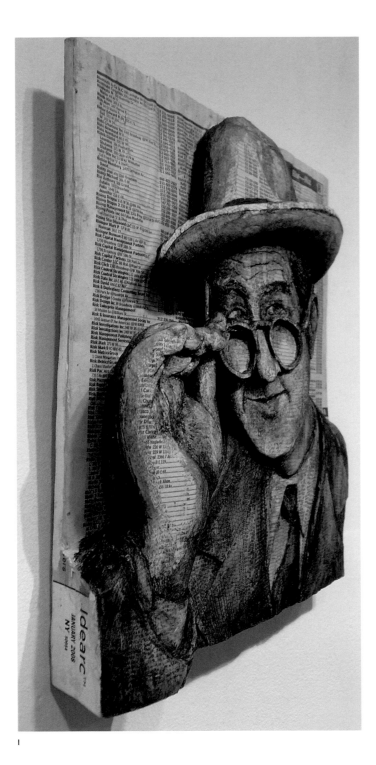

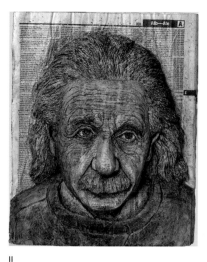

II

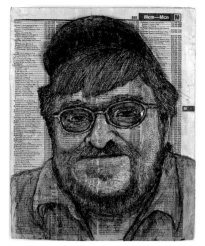

III

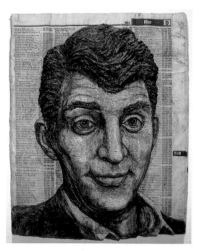

IV

ALEX QUERAL

Taking an ordinary phone book, **ALEX QUERAL** carves a face into this object of so many faceless names. With a very sharp X-Acto knife, a little pot of acrylic medium to set detail areas, and a great deal of craft, Queral literally peels away the pages of the book as if they were the layers of an onion to reveal the portrait within. Once the carving is complete, he will often apply a black wash to enhance the features and then seal the entire book with acrylic to preserve the work. However, he never loses the line registration, and the book remains quite pliable.

I

I See You (Phil Silvers), 2011 (detail). Acrylic on carved New York City residential telephone directory.

II

It's All Relative (Albert Einstein), 2010. Acrylic on carved Philadelphia residential telephone directory.

III

He Was Right About Bush (Michael Moore), 2007. Acrylic on carved Philadelphia residential telephone directory.

IV

Amore (Dean Martin aka Dino Paul Crocetti), 2011. Acrylic on carved Philadelphia residential telephone directory.

——

V

*Free Tibet! (His Holi-
ness the Dalai Lama
aka Lhamo Thondup)*,
2008. Acrylic on carved
Philadelphia residential
telephone directory.

VI

*Deputy Fife (Barney
Fife aka Don Knotts)*,
2010. Acrylic on carved
Philadelphia residential
telephone directory.

VII

*Mr. Bean (Rowan
Atkinson)*, 2010. Acrylic
on carved Philadelphia
residential telephone
directory.

VIII

*The Man Who Fell to
Earth (David Bowie)*,
2010. Acrylic on carved
Philadelphia residential
telephone directory.

——

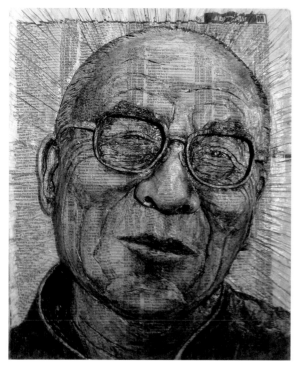

V

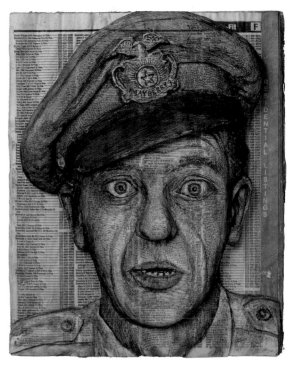

VI

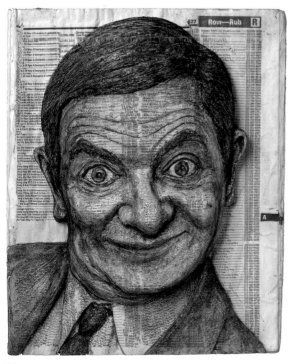

VII

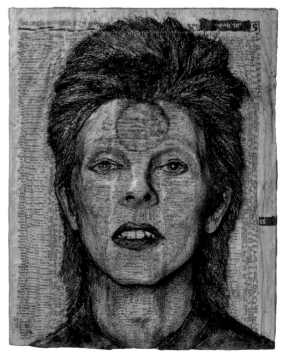

VIII

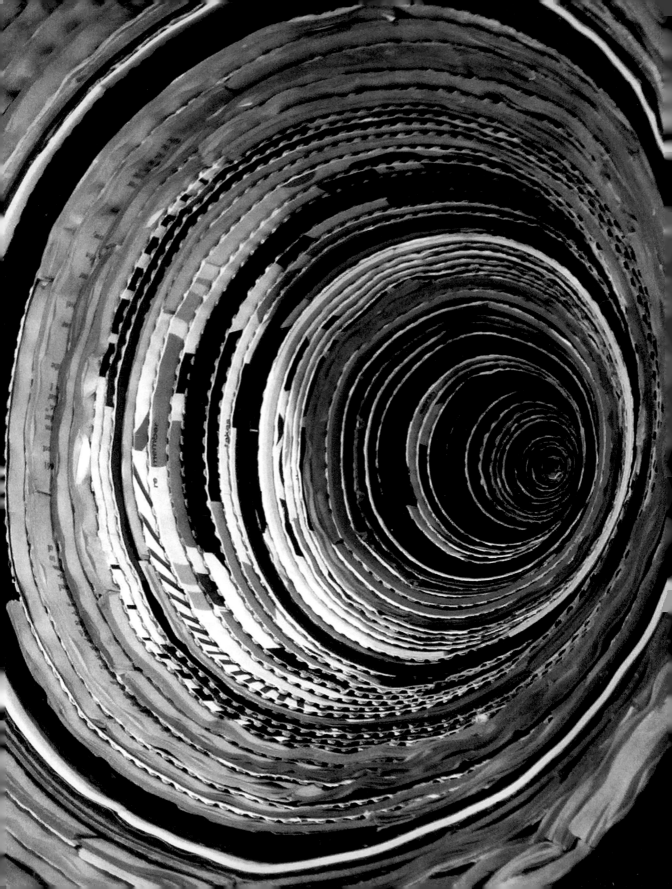

JACQUELINE RUSH LEE

I, II (OPPOSITE)

In Media Res: Vascellum
2009–2012. Manipulated
book components and
archival glue.

JACQUELINE RUSH LEE transforms books into sculptures
by applying various physical and conceptual practices. Drawn
to the complexity of the book as familiar object and archetypal
form, she scrambles its formal arrangement and creates new
narratives. She selects her books carefully and her response
to each is unique. Most of the techniques Rush Lee employs
are informed by both traditional and nontraditional artistic
practices. She utilizes components inherent in the books
themselves, such as inks, covers, pages, bookmarks, and
headbands. Most of her "residual" sculptures or installations
emerge as a palimpsest—something that bears traces of the
original text within its framework but possesses a new narra-
tive as a visual document of another time.

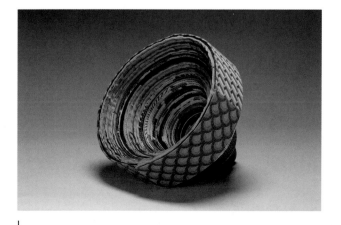

I

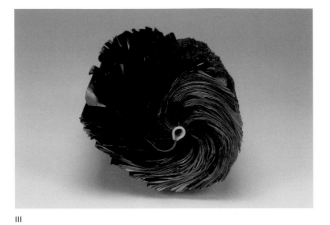

III

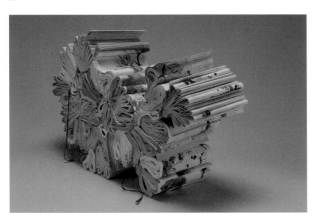

IV

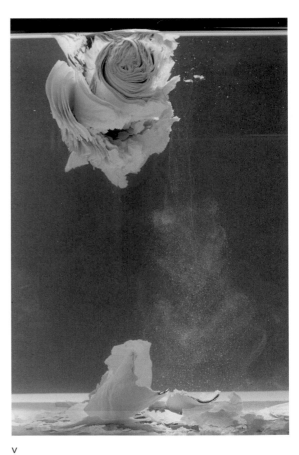

V

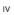

─────

III

Peacock, from the series *Devotion*, 2008. Used book, hand-painted ink.

IV

Lorem Ipsum III, 2010–2012. Book components, hand-stitching, archival glue.

V

Absolute Depth, from the series *Ex Libris*, 2000. Installation of fired periodical shedding text in water.

VI

Anthologia, from the series *Devotion*, 2008 (detail). Used hand-painted, sanded, and assembled books, burnished inks, bookmarks, archival glue.

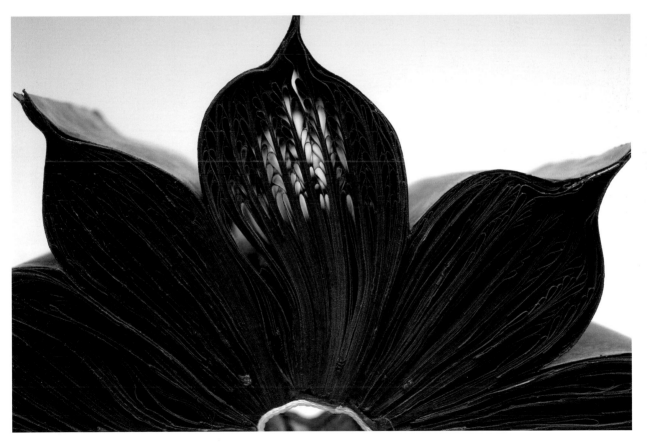

VI

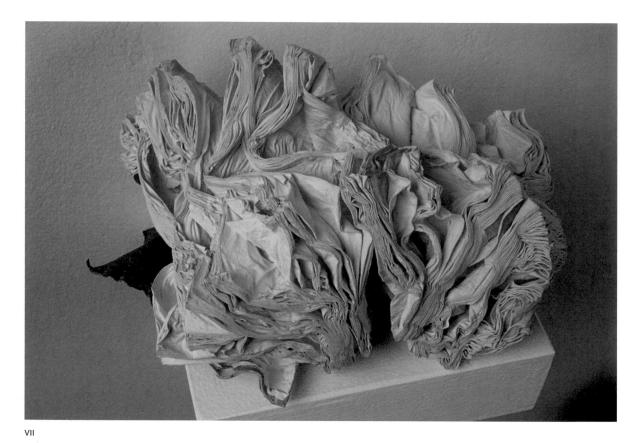

VII

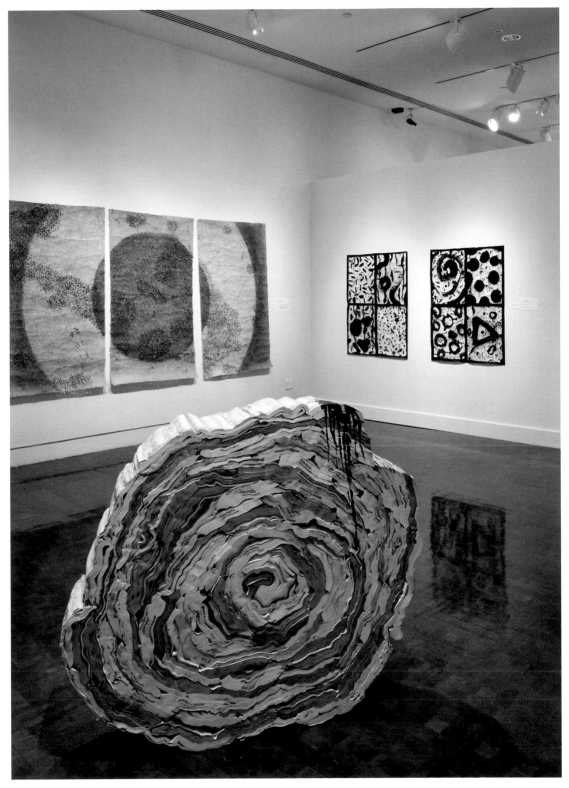

VIII

I

GEORGIA RUSSELL

GEORGIA RUSSELL slashes, cuts, and dissects printed matter,
transforming books, music scores, maps, newspapers, and
photographs. The atmosphere of her original material is signifi-
cant in conveying her feelings and ideas, and it is an emotional
experience for her to destroy a book and literally take apart the
layers of meaning in the text. Russell's cut bookworks are often
displayed like exotic specimens in antique glass bell jars, and
although she hints at organic forms, they are not described lit-
erally. Her dissected books are both object and image, and any
original elements that survive her process become a reference
to their past existence.

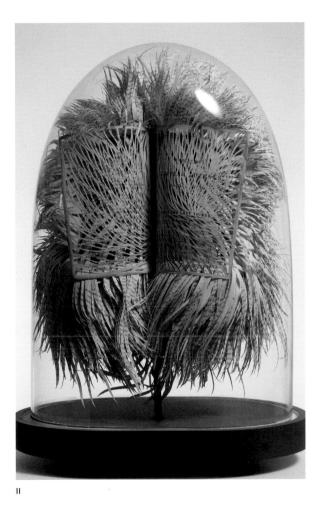

II

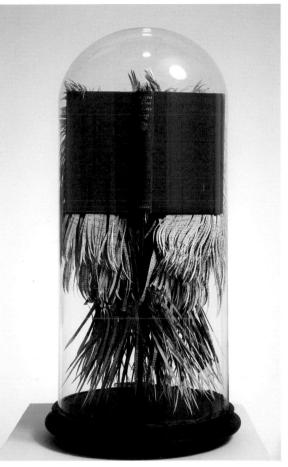

III

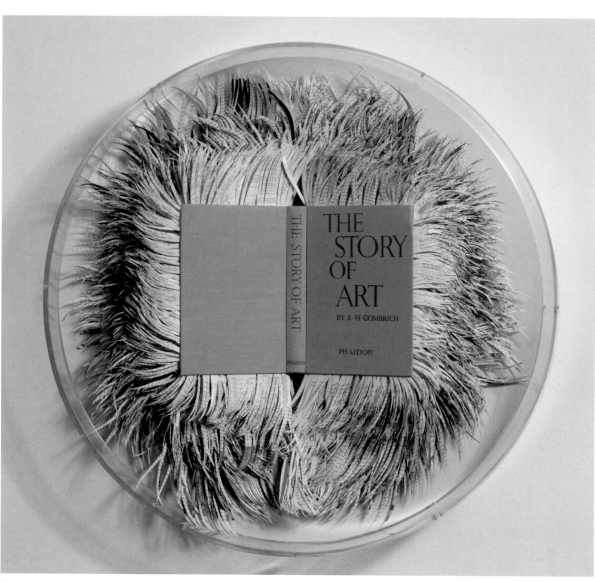

IV

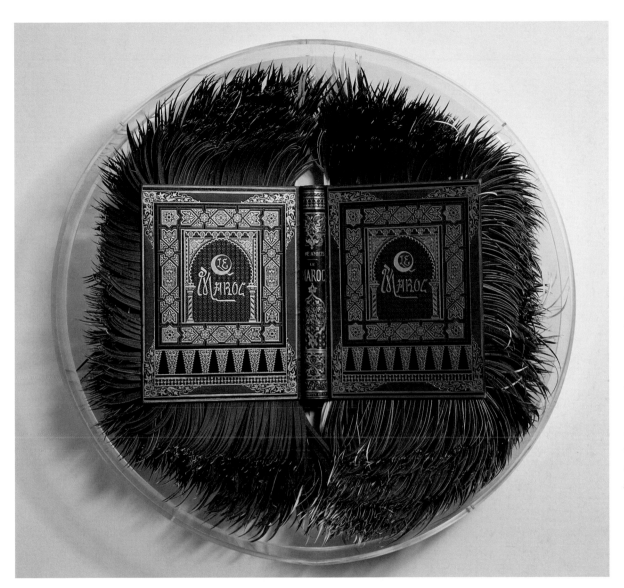

V

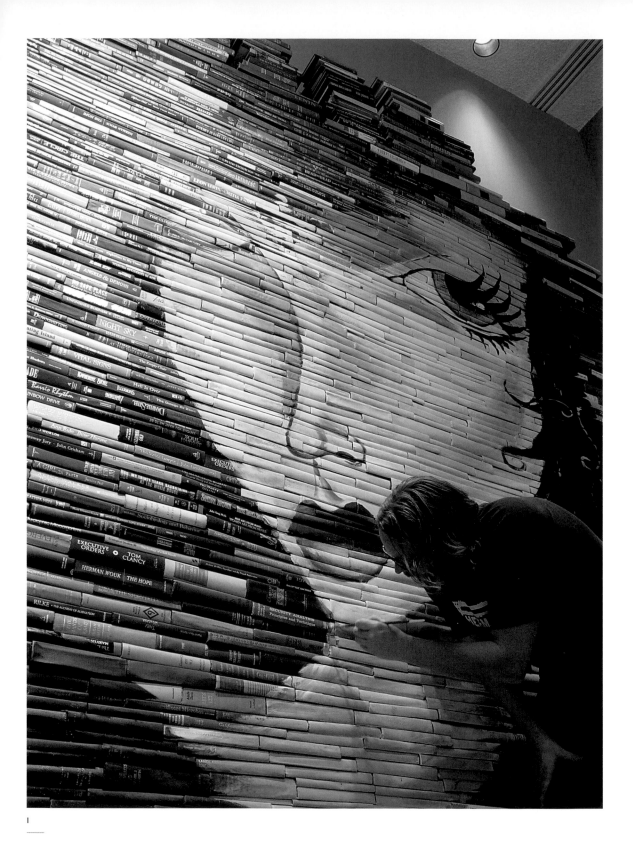

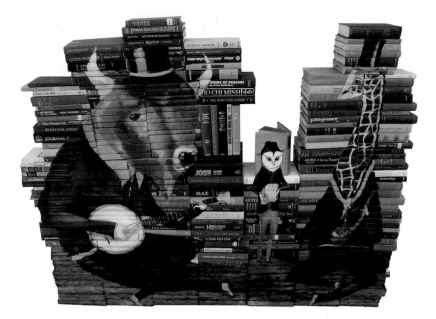

II

MIKE STILKEY

I

When the Animals Rebel,
2007 (detail). Acrylic on
books. Installation at Rice
Gallery, Houston, Texas.

II

The Fantastic Five, 2011.
Acrylic on books.

MIKE STILKEY looks to everyday life for his artistic inspira-
tion and ideas. He sees potential in vintage or used objects,
such as records, books, furniture, and anything that has a
history. His canvas for painting and drawing is paper, album
covers, book pages, and even book covers. Stilkey imagines
the story behind each object and seeks to convey it in his
site-specific book installations and paintings. Also inspired by
music, he often listens to a song and visualizes the painting
or image that could accompany it. Using a mix of ink, colored
pencil, paint, and lacquer, Stilkey depicts a melancholic and
at times whimsical cast of characters that inhabit ambiguous
spaces and narratives of fantasy and fairy tales.

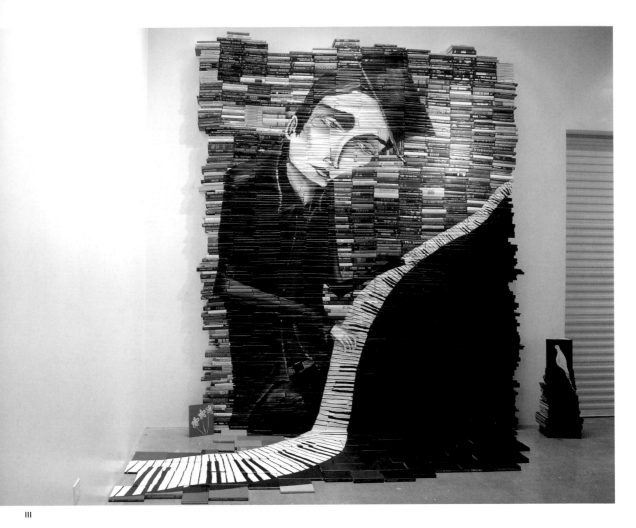

III

The Piano Has Been Drinking, 2010. Acrylic on books. Installation at Hurley International, Costa Mesa, California.

IV

Lovers All Untrue, 2011. Acrylic on books.

V

Falling for You, 2010. Acrylic on books.

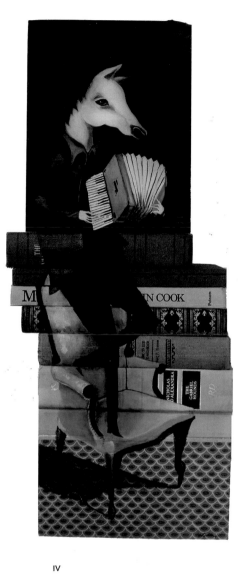

IV

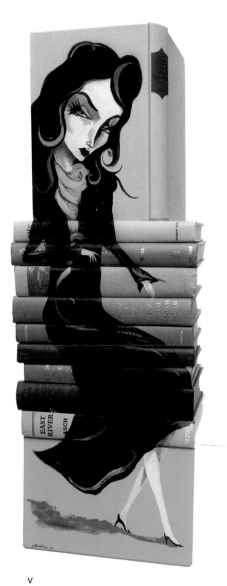

V

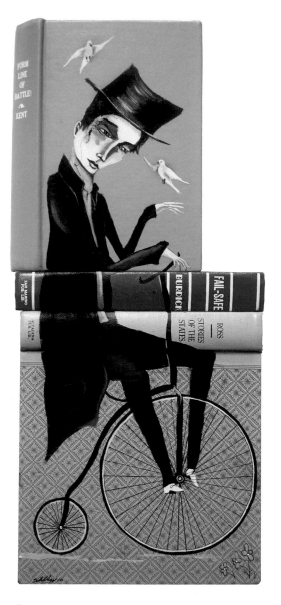

VI

VI

Birds Attack Man on Bike, 2010. Acrylic on books.

VII

Reminiscent, 2010. Acrylic on books. Installation at Hurley International, Costa Mesa, California.

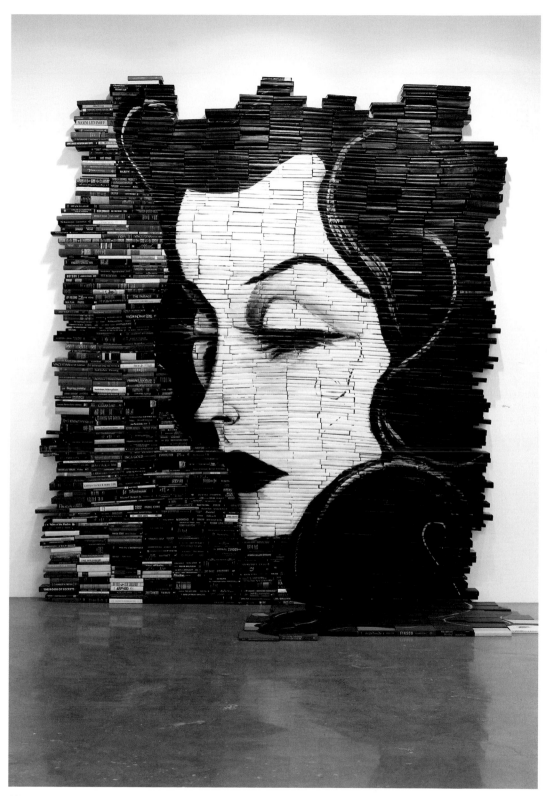

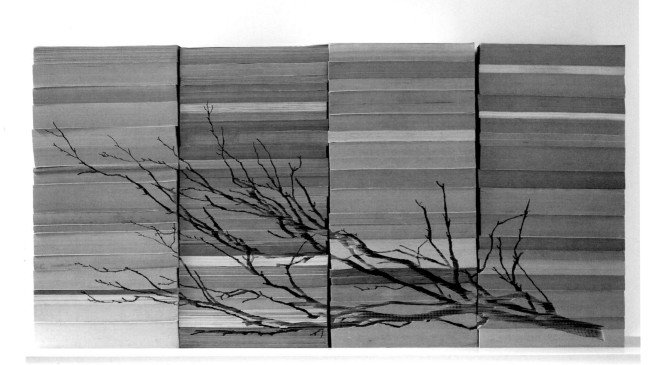

I

Filtering modern art and craft traditions through her own inventive sensibility, Melbourne-based artist **KYLIE STILLMAN** transforms common materials into divine works of art. Her sculptures reveal a dexterous ability to work with a range of materials, from paper stacks and timber constructs to outdated book volumes, plastic bottles, and Venetian blinds. Dating from 1999, her work has explored aspects of the natural world and ways in which it can be captured, represented, and cultivated in tamed environments. The artist's enchanting and skillfully crafted work creates an intriguing sense of narrative through its careful interplay of presence and absence.

KYLIE STILLMAN

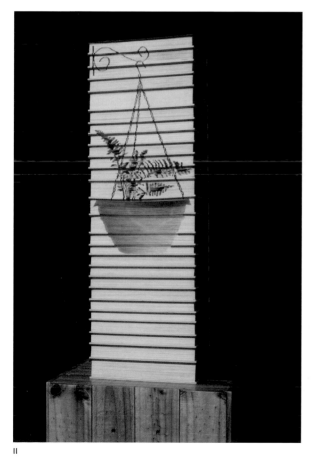

II

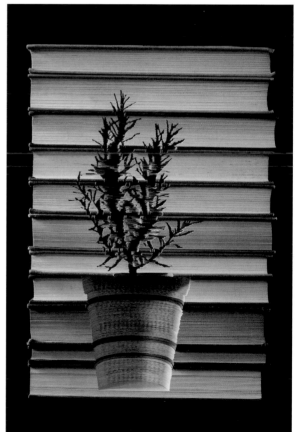

III

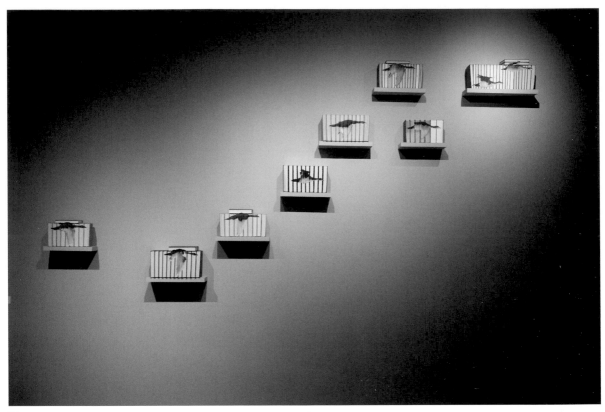

IV

IV

Flock, 2007. Installation at the Museum of Contemporary Art Taipei, 2012.

V

European Goldfinch, 2008.

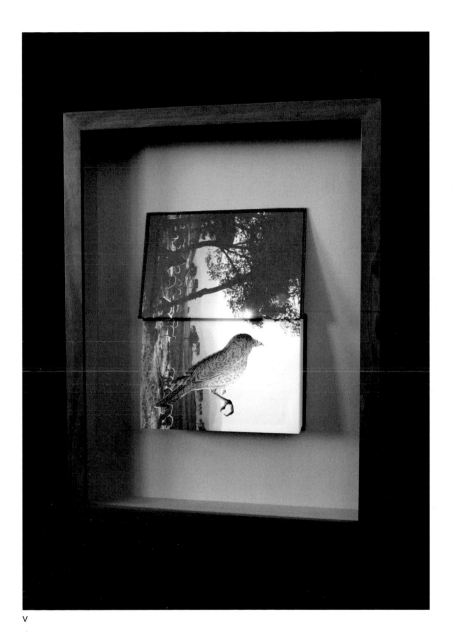

V

153

JULIA STRAND

JULIA STRAND rescues books from garage sales, second-hand shops, and estate sales. Using X-Acto knives, rotary cutters, tweezers, pliers, and files, she deconstructs these books and refashions them into topographical landscapes, paper specimen boxes, and three-dimensional collages of the original contents. Her favorite subjects are reference books, several editions out of date. No longer valued for the information they contain, these books are given a second opportunity to be appreciated through her carvings.

I

Topographical Funk & Wagnalls, 2010. (*Funk & Wagnalls Standard Reference Encyclopedia,* 1963)

II

Practical Standard Dictionary, 2010 (detail). (*Funk & Wagnalls Practical Standard Dictionary,* 1931)

III

Webster's Diptych, 2011 (detail). (*Webster's 3rd New International Dictionary of the English Language,* Unabridged, 1966)

I

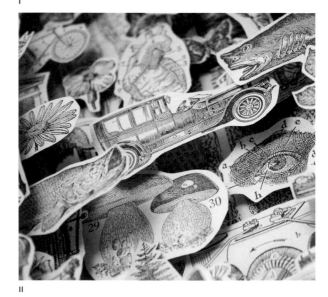

II

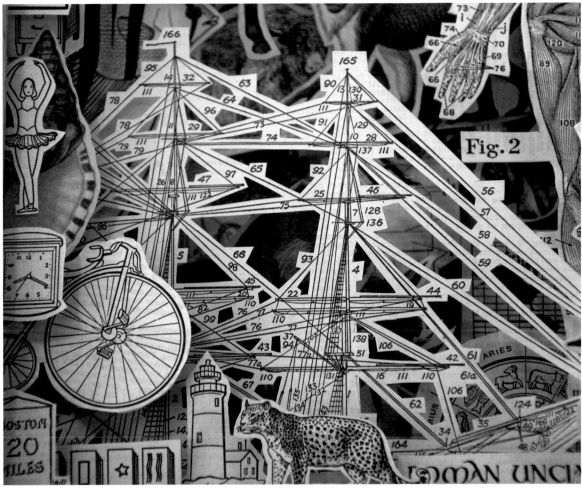

IV

Double-sided Gray's Anatomy, 2011
(front). (*Gray's Anatomy,* 1991)

V

Double-sided Gray's Anatomy, 2011
(back). (*Gray's Anatomy,* 1991)

VI

Webster's Diptych, 2011 (detail).
(*Webster's 3ʳᵈ New International
Dictionary of the English Language,*
Unabridged, 1966)

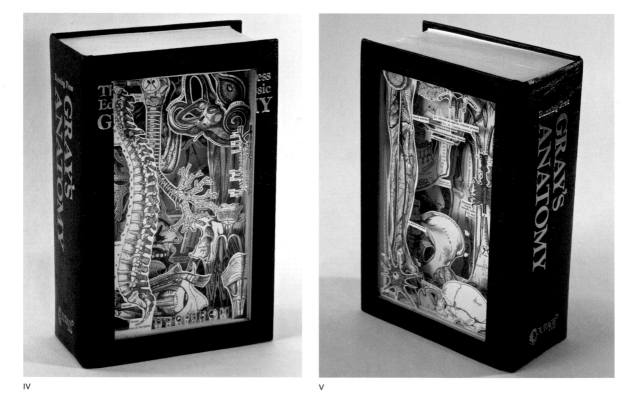

IV

V

VI

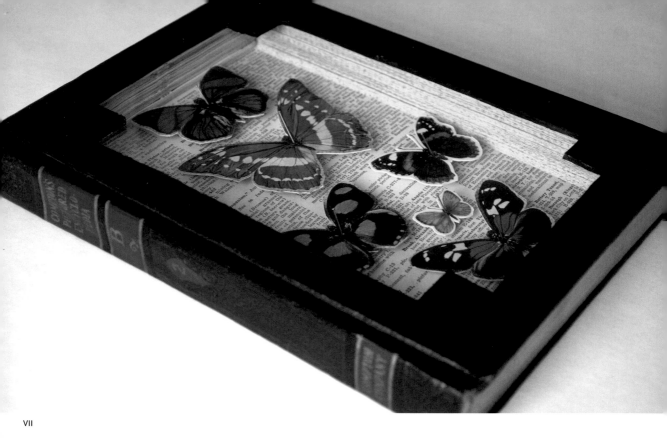

VII

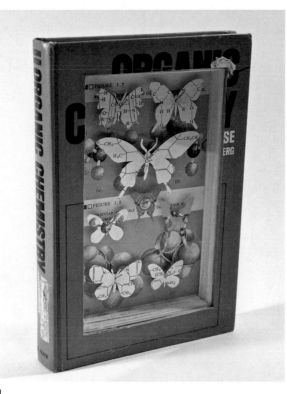

VIII

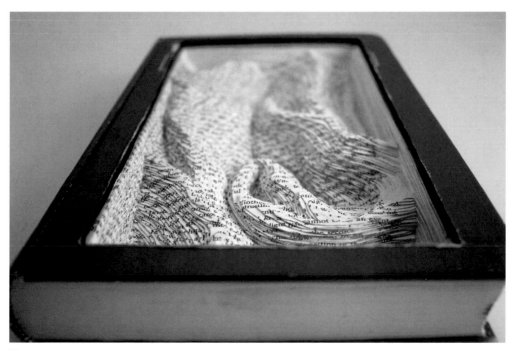

IX

ROBERT THE

Obsession with the semiotic erosion of meaning leads **ROBERT THE** to create objects that evangelize their own relevance by a direct fusion of word and form. Books—many culled from dumpsters and thrift store bins—are lovingly vandalized back to life so they can assert themselves against, and reflect back on, the culture that turned them into debris. Drawn to what is tweaked and discordant, The engages text to draw inspiration for his forms, and infuses them with a fierce wit and irony.

I, II

Tractatus, 2004. (*Tractatus Logico Philosophicus*, Ludwig Wittgenstein)

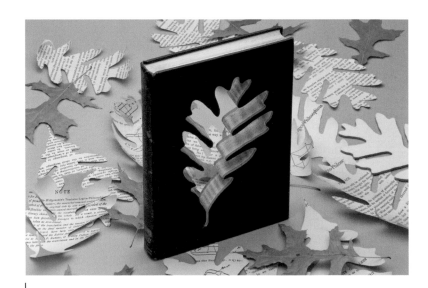

I

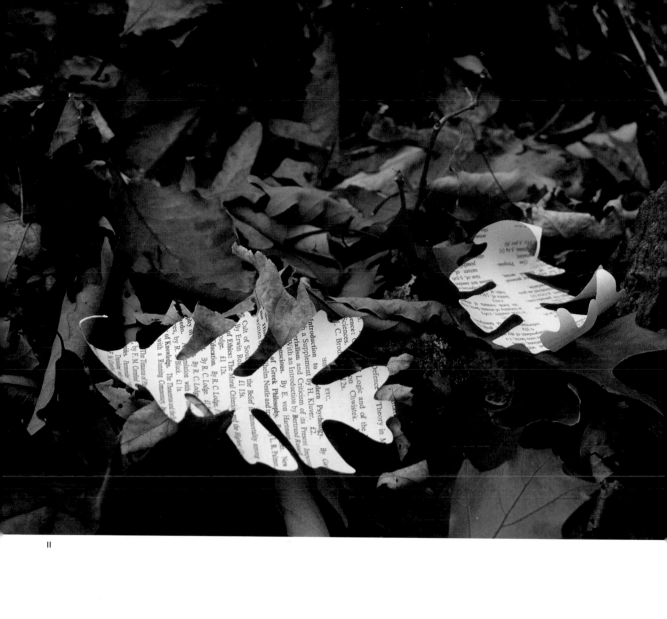

II

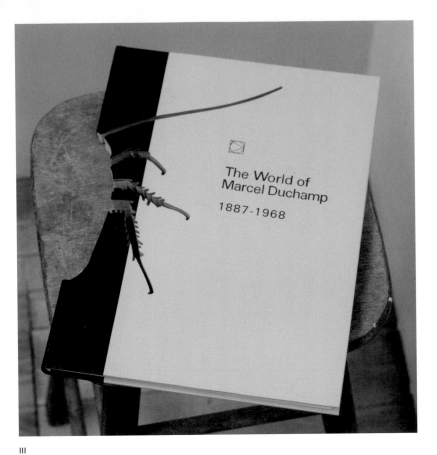

III

Duchamp, 2008.
(*The World of Marcel Duchamp, 1887–1968*,
Time-Life Library of Art)

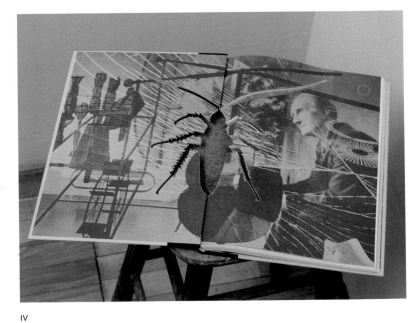

IV

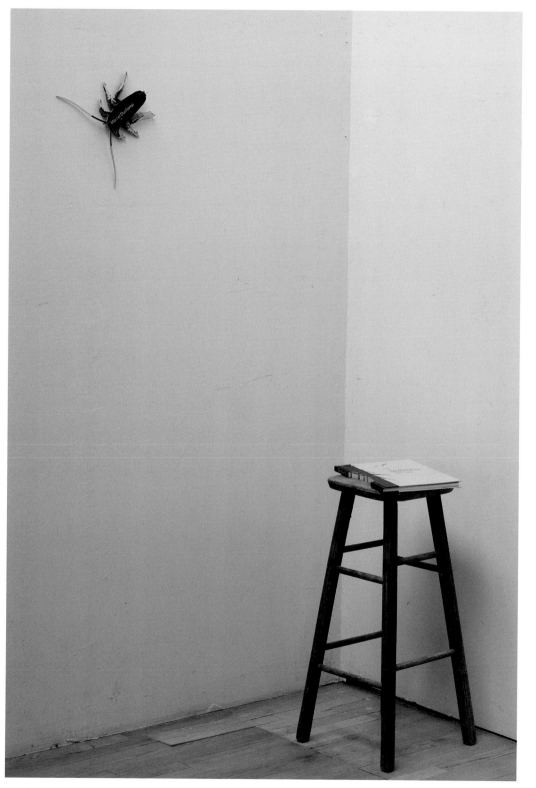

v

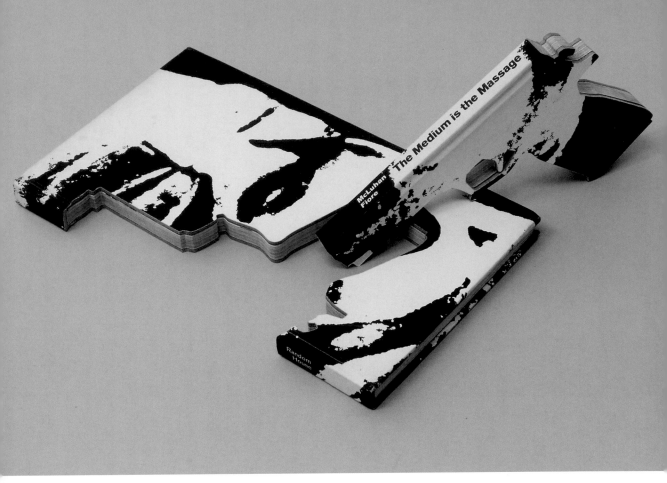

VI

The Medium is the Message, 2006. (*The Medium is the Massage,* Marshall McLuhan and Quentin Fiore, 1967. The title is a variation on McLuhan's noted phrase "The medium is the message.")

VII, VIII

Object/Objectif, 2006. (*Objet/Objectif,* Rainer Crone and David Moos)

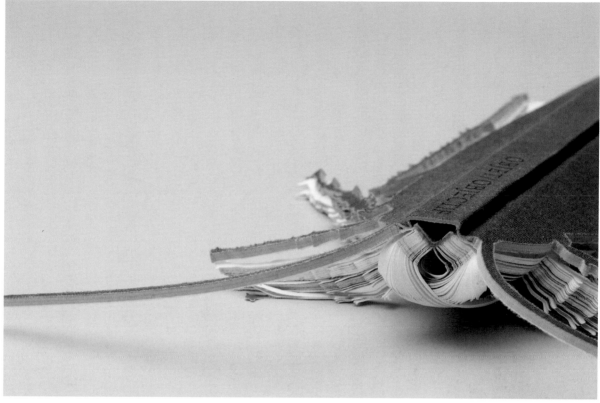

VII

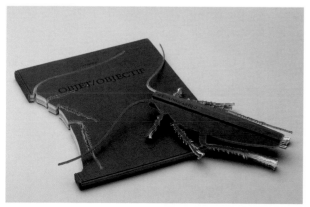

VIII

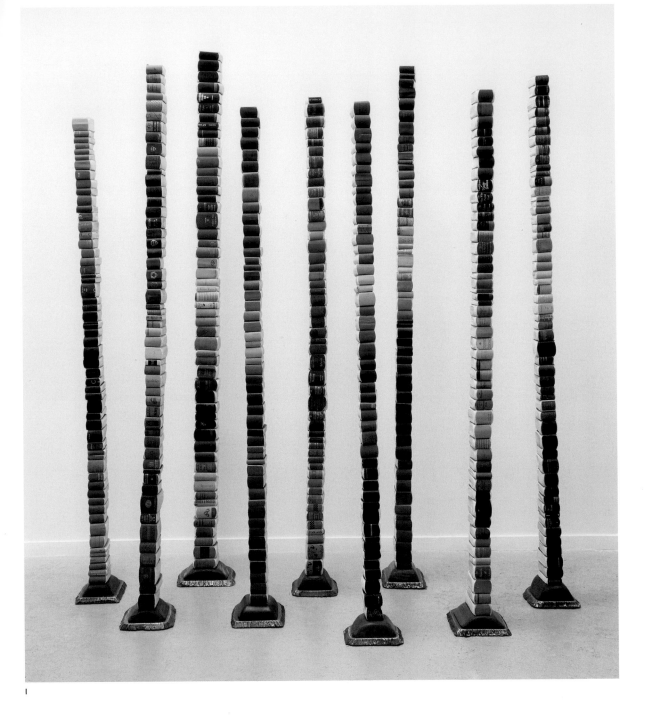

I

VITA WELLS

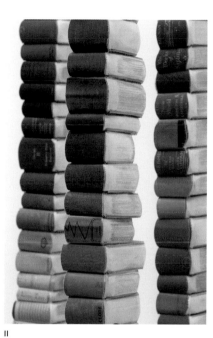

II

III

I–III

Still Standing,
2009–2011. Books,
steel, wood, glue.

Perception has been a core theme in **VITA WELLS**'s work over
the years, particularly in relation to how people form identi-
ties and find meaning in their lives. She is interested in what
contributes to how we see ourselves and the world around
us—from our neurological functioning to our psychological
structure to our social context—and the significant role of
reading in the process. Through her manipulations of books,
Wells explores the discretionary and changeable character
of perception. Her intent is to prompt reflection on what we
think we know.

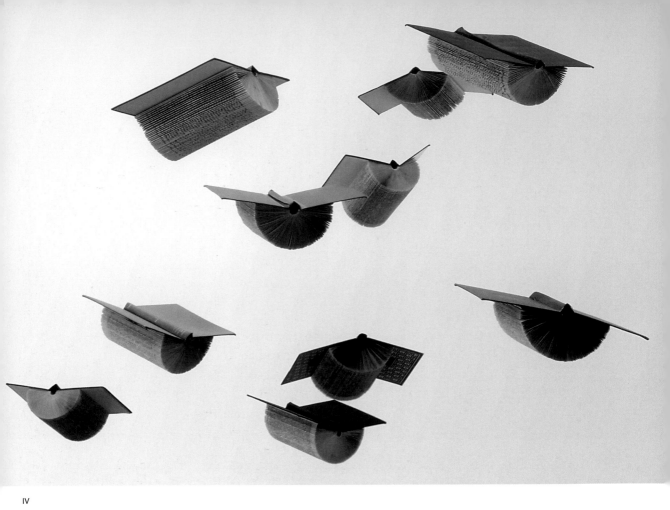

IV

IV

Flights of Mind, 2012.
Books, filament. Installa-
tion at Oakopolis Gallery,
Oakland, California.

V, VI

Unabridged, 2007. Book,
hair, lights, fan, key,
screws, hinges, glue.

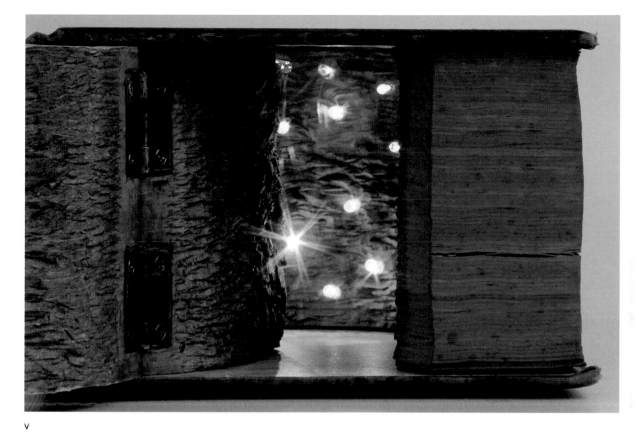

V

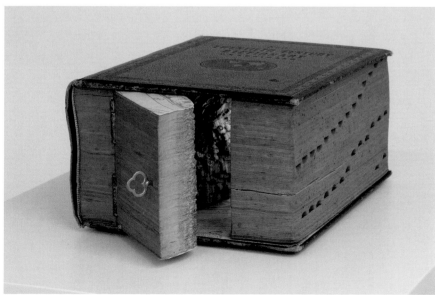

VI

ARTIST BIOS

JAMES ALLEN

Originally from Great Lakes, Illinois, James Allen (American, born 1977) currently lives and works in Seattle, Washington, where he is represented by Winston Wächter Fine Art. He earned a Bachelor of Fine Arts from the University of Wisconsin-Milwaukee in 2000. Allen's artwork was included in *The Book Borrowers: Contemporary Artists Transforming the Book* at the Bellevue Arts Museum in 2009. He has also exhibited in many cities across the United States, including New York, Chicago, and Miami.
(www.winstonwachter.com)

THOMAS ALLEN

Thomas Allen (American, born 1963) is a career artist and illustrator. His photographs of reimagined pulp novels have appeared in both print and online media, including *Harper's*, the *Wall Street Journal*, and National Public Radio. Allen is represented by Foley Gallery (New York) and G. Gibson Gallery (Seattle). Allen's monograph, *Uncovered: Photographs by Thomas Allen*, was published by Aperture Foundation in 2007. He lives in southwest Michigan where he is a beekeeper in the summer, makes maple syrup in late winter, and produces handmade soap all year round.
(www.thomasallenonline.com)

NORIKO AMBE

Currently living and working in New York and Tokyo, Noriko Ambe (Japanese, born 1967) received a Bachelor of Fine Arts in oil painting from Musashino Art University in Tokyo in 1990. She began working with paper in 1999 with her project *Linear-Actions Cutting / Drawing*. In her works, Ambe individually cuts and stacks thousands of pieces of paper to create an original topography. She has had solo shows at Pierogi Gallery (Brooklyn, New York), Josee Bienvenu Gallery (New York), The FLAG Art Foundation (New York), Lora Reynolds Gallery (Austin, Texas), and SCAI The Bathhouse (Tokyo), and group shows at the Museum of Arts and Design (New York), and The Drawing Center (New York), among others. Her work is in the permanent collections of the Museum of Modern Art, New York, and the Whitney Museum of American Art, New York.
(www.norikoambe.com)

ANONYMOUS

In every city there are special places that enliven our days and color our dreams. Anonymous's work was conceived in support of such places. By placing each piece in a public space, the artist ensured that they could be encountered just as one comes across a book on a shelf, its form only hinting at a greater alchemy that turns symbols on paper into living stories. It is not that the artist is playing hard to get by choosing to remain anonymous; the work simply insists that she remain a mystery, and in the artist's words, "Anyway, mysteries are fun."
(www.thisiscentralstation.com/featured/mysterious-paper-sculptures)

CARA BARER

Cara Barer (American, born 1956), originally from Freeport, Texas, graduated from the Art Institute of Houston and then moved into a studio and began painting and printmaking.

She furthered her studies of art and photography at the University of Houston, and the Glassell School of Art at the Museum of Fine Arts, Houston. After becoming inspired by a weathered phone book on the sidewalk in 2004, her work changed and her focus has been on sculpture and photography of books ever since. Barer's work is in public and private collections throughout the world, and she is represented in galleries in the United States, Canada, and Europe.
(www.carabarer.com)

DOUG BEUBE

Doug Beube (Canadian, n.d.) is a mixed-media artist living in Brooklyn, New York, who works in bookworks, collage, sculpture, and photography. Beube received a Master of Fine Arts in photography from the Visual Studies Workshop (Rochester, New York) in 1983. He regularly lectures and exhibits his work throughout Canada, Europe, and the United States, and his work can be found in both private and museum collections. Since 1993 he has curated the private collection of Allan Chasanoff, titled *The Book Under Pressure*, in New York City. Beube's monograph, *Doug Beube: Breaking the Codex*, was published in the fall of 2011. David McFadden, chief curator of the Museum of Arts and Design (New York) wrote the introduction and several writers discuss the art Beube has made over the past thirty years.
(www.dougbeube.com)

SU BLACKWELL

Born in Sheffield, United Kingdom, Su Blackwell (British, born 1975) resides in London and works predominantly with paper and books. Since graduating from the Royal College of Art in London in 2003, Blackwell has worked as an artist-in-residence and has exhibited at the Bronte Parsonage Museum in Haworth, West Yorkshire, and the Museum of Arts and Design in New York. Blackwell has a broad practice: Her designs are used in gift cards produced by Roger la Borde; she has collaborated with Nicole Farhi and *Vogue*; and she has worked on international advertising campaigns for Cartier, Crabtree & Evelyn, and the Fairmont Hotels. Blackwell also created beautiful illustrations for a book of fairy tales published by Thames & Hudson. Blackwell is represented by Long and Ryle Gallery, London.
(www.sublackwell.co.uk)

JENNIFER COLLIER

Jennifer Collier (British, born 1977) lives in Stafford, United Kingdom, where she works from her gallery, Unit Twelve, which she established in 2010. She originally trained in textiles, completing a Bachelor of Arts with honors in textiles at Manchester Metropolitan University (UK) in 1999. Although her studies were traditional and she specialized in printing, knitting, and weaving, all the methods she now employs were self-taught through experimentation with different media and techniques. Collier exhibits nationally and internationally, and her work has been featured in magazines such as *Vogue* and *Elle Decoration*. She makes work on commission, undertakes art workshops, and runs her gallery space.
(www.jennifercollier.co.uk)

BRIAN DETTMER

Originally from Chicago, Brian Dettmer (American, born 1974) currently resides in Atlanta, Georgia. Dettmer has had solo shows in New York, Chicago, San Francisco, Atlanta, and Barcelona. His work has been exhibited throughout North America and Europe at galleries and museums, including the Museum of Arts and Design in New York, the Museum of Contemporary Art of Georgia, the International Museum of Surgical Science in Illinois, and the Museum Rijswijk in the Netherlands. Dettmer's bibliography includes the *New York Times*, *ArtNews*, *The Guardian*, *Telegraph*, *Chicago Tribune*, *Modern Painters*, *Wired*, the *Village Voice*, and National Public Radio.
(www.briandettmer.com)

ARIÁN DYLAN

Arián Dylan (Mexican, born 1984) received his degree in visual art from the National School of Painting, Sculpture, and Printmaking, "La Esmeralda," in Mexico City. He has obtained art scholarships, such as the Young Creators Fellowship from Mexico's National Fund for Culture and the Arts in 2010–2011, and has held art residences in Canada in 2005 and the United States in 2008. In 2011, Dylan received the Eco Creación award for a design and sustainability competition in Mexico. He has participated in individual and group exhibitions in Japan, Spain, Canada, the United States, Chile, China, and Mexico. He is currently in a Masters program at the National University of the Arts in Buenos Aires, Argentina. Dylan is represented in Mexico by La Estación Arte Contemporaneo (Chihuahua) and Galeria Massimo Audiello (Mexico City), and by Seager Gray Gallery (Mill Valley, California) in the United States. (www.ariandylan.com)

YVETTE HAWKINS

Yvette Hawkins (British, born 1979) is a paper artist of South Korean and English descent who makes installations and sculptural objects using books, maps, and other found materials. Hawkins trained at the Glasgow School of Art and graduated from Newcastle University in 2007. She has had numerous group and solo exhibitions within the United Kingdom and Spain. She also works on commission and has pieces in collections in Italy, Japan, and the United States. Her work has been featured in books and magazines and was included in *Book Art: Iconic Sculptures and Installations Made From Books* (Gestalten, 2011). Hawkins is currently represented by Globe Gallery, United Kingdom. (www.yvettehawkins.com)

NICHOLAS JONES

Born in the United Kingdom, Nicholas Jones (Australian, born 1974) completed a Bachelor of Fine Arts at the Victorian College of the Arts in Melbourne in 1997, and a Master of Fine Arts at the Royal Melbourne Institute of Technology in 2001. His work has been shown in a number of solo exhibitions, including *The Garden of Forking Paths* at Geelong Art Gallery in Australia, and he has taken part in many group exhibitions in Australia, North America, and South America. Jones's work has been featured in several publications, including *Make the Common Precious* (Craftsman House), *Book Art* (Gestalten), and *Where They Create* (Frame), and he is represented in numerous public and private collections in Australia. (www.bibliopath.org)

JENNIFER KHOSHBIN

Originally from Philadelphia, Jennifer Khoshbin (American, born 1968) was exposed to art at an early age: her grandfather and uncle are master carpenters and her mother is a ceramic artist. Khoshbin studied Fine Arts and Sociology at the University of Texas, Austin, and the University of Kentucky. She has exhibited in galleries and museums throughout the United States, and her work has been featured in several art and craft books and magazines, including *Readymade*, *House Beautiful*, *Glamour*, and *Spaces*. She also collaborates with her husband, Paul Lewis, on public works under the name Refarm Spectacle. Khoshbin currently lives in San Antonio, Texas, with her husband and their two children. (www.jenkhoshbin.com)

LISA KOKIN

Lisa Kokin (American, born 1954) lives in El Sobrante, California, with her partner, Lia Roozendaal, three Chihuahua studio assistants, and Bindi the cat. The daughter of upholsterers, Kokin stitches everything she can get her hands on, including discarded books which she rescues from the local recycling center. Kokin received

her Bachelor of Fine Arts and Master of Fine Arts from the California College of the Arts in Oakland, California, and she is the recipient of numerous awards and commissions. Her work appears in many private and public collections in the United States and abroad. Kokin is represented by Seager Gray Gallery in Mill Valley, California, Tayloe Piggott Gallery in Jackson, Wyoming, and Gail Severn Gallery in Sun Valley, Idaho.
(www.lisakokin.com)

GUY LARAMÉE

Over the course of his thirty years of practice, interdisciplinary artist Guy Laramée (Canadian, born 1957) has created in such varied disciplines as theater writing and directing, contemporary music composition, musical instrument design and building, singing, video, scenography, sculpture, installation, painting, and literature. He has received more than thirty arts grants and was awarded the Canada Council for the Arts' Joseph S. Stauffer Prize for musical composition. His work has been presented in theaters, museums, and galleries in the United States, Belgium, France, Germany, Switzerland, Japan, and Latin America. Parallel to his artistic practice, Laramée has pursued investigation into the field of anthropology, and ethnographic imagination is an important theme in his artistic work.
(www.guylaramee.com)

PABLO LEHMANN

Pablo Lehmann (Argentinean, born 1974) graduated from the National School of the Arts (IUNA) in Buenos Aires, and since 2000 he has been a professor there. He has had solo exhibitions at Black Square Gallery (Miami), Carla Rey Arte Contemporáneo (Buenos Aires), 1/1 Caja de Arte (Buenos Aires), and Matthei Gallery (Santiago, Chile). Lehmann's group exhibitions include the Philips de Pury & Company auction in London and the Sívori Museum, Bicentennial edition auction, in Argentina. He has also participated in art fairs, such as Art Chicago, Scope Miami, Scope New York, Miami International Art Fair, ArtBo—Bogotá, ArteBa—Buenos Aires, and Buenos Aires Photo. Lehmann has twice received the Salón Nacional de Arte Textil award.
(www.pablolehmann.com.ar)

JEREMY MAY

Jeremy May (British, born 1976) is a landscape architect originally from Suffolk, United Kingdom. May received his Bachelor of Arts from the University of Greenwich, and after having worked in his field of design over ten years, created his first paper ring in September 2007. He launched his brand Littlefly to the public in January 2009, aspiring to bring joy and color to sustainably minded individuals by transforming paper into lasting beauty. May's jewels have been presented in London, Paris, Osaka, Athens, Hamburg, Saint Petersburg, and New York. Currently May is working on private commissions and on creating collections of jewels under a thematology to be presented in exhibitions around the world. He lives and works in London.
(www.littlefly.co.uk)

PAMELA PAULSRUD

Pamela Paulsrud (American, born 1951), a visual artist recognized internationally as a papermaker, calligrapher, book artist, and collaborator, creates both intimate pieces and large-scale installations. Paulsrud's exploration in energy and vibration, letters and lines, and her love of the land and the earth and its resonance inspires both her work and her life. Her work is included in numerous private and public collections and has been published in many magazines, books, and journals. She teaches workshops in lettering and book arts. Paulsrud is also extremely passionate about an ongoing project that she co-created titled Treewhispers (www.treewhispers.com), an international collaboration awakening our heartfelt connection to trees. Paulsrud is represented in the United States by Seager Gray Gallery in Mill Valley, California, and 23 Sandy Gallery in Portland, Oregon.
(www.pamelapaulsrud.com)

SUSAN PORTEOUS

Susan Porteous (British, born 1980) received a Bachelor of Arts with honors in Fine Art from the University of Leeds in 2003 and a Master of Fine Arts from California State University, Long Beach, in 2008. Since then she has continued to explore both sculptural and traditionally bound books while investigating issues of form, content, word, and image using handmade and commercial production methods. Porteous exhibits work in juried and invitational exhibitions throughout the United States and Europe, and her work has been purchased by several public and private collections and included in various publications on book art. She currently lives and works in Denver, Colorado.
(www.susanporteous.net)

ALEX QUERAL

Alex Queral (Cuban, born 1958) and his family migrated from Havana to Mexico and then to Miami when he was a young boy. He received a Bachelor of Fine Arts from the University of Washington, Seattle, and a Master of Fine Arts from the University of Pennsylvania. His works have been exhibited in Canada, China, England, Mexico, and throughout the United States, and they appear in the collections of Ripley's Believe It or Not!, Jerry Speyer, and the Kohler family. Queral's carved telephone books are exclusively represented by Projects Gallery in Philadelphia and Miami. Several of his phone books are now available as high-resolution photographic images in a variety of sizes.
(www.projectsgallery.com/Queral.html)

JACQUELINE RUSH LEE

Jacqueline Rush Lee (Anglo-Irish, born 1964), a sculptor who lives and works in Hawaii, is recognized for her innovation in working with the book form. Her artworks are featured in numerous books, blogs, magazines, and the international press, including *Book Art: Iconic Sculptures and Installations Made from Books* (Gestalten), *Papercraft: Design and Art with Paper* (Gestalten), the *New York Times*, the *Washington Post, Courrier International, Sculpture Magazine, DPI Magazine, Taiwan,* and *Focus*, among others. Rush Lee exhibits her artwork internationally and her work is in private and public collections.
(www.jacquelinerushlee.com)

GEORGIA RUSSELL

Georgia Russell (Scottish, born 1974) has lived and worked in France over the past decade. Russell studied at Aberdeen University, Scotland, and graduated from London's Royal College of Art in 2000. Her many solo and group exhibitions in London, France, and the United States have included *Slash: Paper Under the Knife* at the Museum of Arts and Design, New York in 2009–2010. Russell's work has been featured in books and magazines in Europe and the United States, and she is represented in the collections of the Victoria and Albert Museum in London and the Pompidou in Paris.
(www.englandgallery.com)

MIKE STILKEY

Los Angeles native Mike Stilkey (American, born 1975) has always been attracted to painting and drawing on vintage ephemera, including books. His work has been exhibited throughout the United States and internationally in galleries and museums, including the Bristol City Museum and Art Gallery (UK), LeBasse Projects and Kinsey/DesForges Gallery (Culver City, California), David B. Smith Gallery (Denver, Colorado), Gilman Contemporary (Ketchum, Idaho), and the Rice University Gallery (Houston, Texas). He has also created numerous large-scale installations in Turin, Italy; Bern, Switzerland; Hong Kong; and Beijing. Stilkey lives and works in Los Angeles.
(www.mikestilkey.com)

KYLIE STILLMAN

Kylie Stillman (Australian, born 1975) completed a Bachelor of Fine Arts with honors at Royal Melbourne Institute of Technology in 1999.

She has since held several solo exhibitions and participated in numerous group shows, including *Wonderland*, Museum of Contemporary Art, Taipei (2012), *2008 Adelaide Biennial of Australian Art*, Art Gallery of South Australia, and *Uncanny: The Unnaturally Strange*, Artspace, Auckland (2005), New Zealand. Stillman has been awarded Australia Council for the Arts' studio residencies in New York (2009) and Milan (2006), and she has been commissioned to create large-scale artworks for Hermés Australia (2011) and Westpac Private Bank (2010). Stillman is represented by Utopia Art Sydney. (www.kyliestillman.com)

JULIA STRAND
Julia Strand (American, born 1983) holds a PhD in Cognitive Psychology and teaches at the college level. She conducts research on the cognitive and perceptual mechanisms underlying human speech perception. Through her research, teaching, and art, she hopes to help others see things in new and unexpected ways. (hokeystokes.blogspot.com)

ROBERT THE
Originally from Carmel, California, Robert The (American, born 1961) studied philosophy and mathematics at the University of Wisconsin, Madison, and sign lettering at the Institute of Lettering and Design in Chicago. He began making book pieces in 1991 and has appeared in solo and group shows throughout the United States and Europe. His works are in both private and public collections, including the Museum of Modern Art (New York), the Walker Art Center (Minneapolis), and the Los Angeles Museum of Contemporary Art. The received the Pollock-Krasner Award in 2011 and is currently archiving the work of Maryanne Amacher. He lives in upstate New York. (www.bookdust.com)

VITA WELLS
Hailing from a family of artists in South Texas, Vita Wells (American, born 1959) has been creating objects since she could wield an X-Acto knife. She's lived and worked in diverse settings through several chapters of life, but reading's privileged place and a reverence for books have been constants in all of them. During many years' involvement with textiles, Wells developed a keen sense for texture, structure, and color. In her bookwork, these aesthetics are in conversation with conceptual content that reflects her lifelong intellectual curiosity and love of scholarship. Wells divides her time between her studio in Berkeley, California, and the Camino de Compostela in France and Spain. (www.vitawells.net)

PAGE 6 *Tower of Babble*, courtesy of the artist and Kinz + Tillou Fine Art.

PAGE 8 *The Book of the Lost,* photo by Jaron James, courtesy of the artist.

PAGES 10-11 Photos by Brian Dettmer.

PAGE 12, V Photo by Guy L'Heureux.

PAGE 12, VI Photo by Stacey Wei.

PAGE 12, VII Photo by Lia Roozendaal/Jaguire Design.

PAGE 13, VIII Photo by Thomas Allen.

PAGE 13, IX Photo by Luke Richardson Photography.

PAGE 14 Photos by Chris Scott.

PAGE 15 Courtesy of the artist.

PAGE 16, XIII Photo by Thomas Allen.

PAGE 17, XIV Photo by Stacey Wei.

PAGE 17, XV Photo by Eva Chloe Vazaka.

PAGE 18, XVI *Autorretrato gritando*, courtesy of the artist.

PAGE 18 *Common Oak,* courtesy of the artist and Utopia Art Sydney.

PAGE 19 *Shiitake*, photo by Cara Barer.

PAGE 20 *Game Text 1,* photo by Daniel Chen.

PAGE 21 Photo by Scott McCue Photography.

PAGE 22 *Les Paravents* photo by England & Co Gallery, London.

PAGES 30-35 Photos by Thomas Allen.

PAGE 36 キル —*Artist Books, Linear-Actions Cutting Project,* photo by Genevieve Hanson, courtesy of the artist and Lora Reynolds Gallery, Austin, Texas.

PAGE 36 Cutting Book Series with Ed Ruscha: *Artists who make pieces, artists who do books*, photo by Noriko Ambe.

PAGE 37 *Art Victims: Damien Hirst*, photo by Robert Boland.

PAGES 38-39 *Flat Globe "Atlas,"* photo by Masa Noguchi.

PAGE 40 *To Perfect Lovers: Felix Gonzalez-Torres*, photo by Tsukasa Yokozawa.

PAGE 41 *The Sand–The Americans: Robert Frank*, photo by Mareo Suemasa, courtesy of the artist and SCAI THE BATHHOUSE, Tokyo.

PAGES 42-47 Photos by Chris Scott.

PAGES 48-53 Photos by Cara Barer.

PAGES 60-61, 63-65 *Pandora Opening Box, The Last Unicorn, Red Riding Hood, The Baron in the Trees,* photos by Jaron James, courtesy of the artist.

PAGES 62-63 *The Snow Queen, Alice: A Mad Tea Party,* photos by Andrew Meredith, courtesy of the artist and Long and Ryle Gallery.

PAGES 66-68 *Cook Book Ballet Slippers, Ladybird Book Baby Shoes, Super 8 Camera, Paper Typewriter*, photos by Iain Perry.

PAGES 67, 69 *Curley Locks Gloves, Nursery Rhyme Knife Set,* photos by Luke Unsworth.

PAGES 70-71 *Saturation Will Result*, courtesy of the artist and Kinz + Tillou Fine Art.

PAGE 72 *American Peoples*, courtesy of the artist and Toomey Tourell Fine Art.

PAGE 73 *Absolute Authority*, courtesy of the artist and Wexler Gallery.

PAGE 73 *Tower of Babble*, detail, courtesy of the artist and Kinz + Tillou Fine Art.

PAGE 74 Photos courtesy of the artist and Packer Schopf.

PAGE 75 Courtesy of the artist and Saltworks.

PAGES 80-81, 84, 85 *No Land In Particular, Nothing to Read Here*, courtesy of Colin Davison and Globe Gallery, United Kingdom.

PAGE 82 *All the Books I Have Never Finished*, photo by Irene Brown.

PAGE 83 *Wall Flower Book Sculptures,* photo by Sarah Deane Photography.

PAGE 84 *All the Books I Have Never Finished,* photo by Yvette Hawkins.

PAGES 86, 88, 90 *The Victorian Australian, Bookworm Ensconced, Gedichte,* photos by James Widdowson.

PAGES 87, 88 *Concise Atlas of the Earth, The Barber of Seville,* photos by Poppy Greenham.

PAGE 89 *Greek Art*, photo by John Gollings.

PAGE 91 *Australian Year Book 1969*, photo by Simon Schluter.

PAGE 95 *Swinging My Way Back*, photo by Toni Frissell.

PAGES 98-103 Photos by Lia Roozendaal/Jagwire Design, courtesy of Seager Gray Gallery, Mill Valley, California.

PAGES 104-109 Photos by Guy Laramée.

PAGES 111-113 *Cut-out screen 1, Baroque Vowel (E), Incompossible Text 1*, photos by Daniel Chen.

PAGE 113 *Naked Book*, photo by Gustavo Lowry.

PAGES 116-121 Photos by Eva Chloe Vazaka.

PAGES 122-125 Photos by Pamela Paulsrud.

PAGES 130-133 Photos by Helen Hyder, courtesy of Projects Gallery, Philadelphia, Pennsylvania.

PAGES 134-135, 136, 137 *In Media Res: Vascellum, Lorem Ipsum III, Anthologia*, photos by Paul Kodama.

PAGE 136 *Absolute Depth*, photo by Brad Goda.

PAGE 138 Photo by Brad Goda.

PAGE 139 Photo by Shuzo Uemoto, installation at the Hawaii Art Now Exhibition, 2012, courtesy the Honolulu Museum of Art.

PAGES 140-143 Photos by England & Co Gallery, London.

PAGES 144 *When the Animals Rebel*, photo by Nash Baker.

PAGES 150-153 Photos courtesy of the artist and Utopia Art Sydney.

PAGES 154, 159 *Topographical Funk & Wagnalls, Practical Standard Dictionary, Topographical Theories of Personality*, photos by Jon Strand.

PAGES 155-159 *Webster's Diptych, Double-sided Gray's Anatomy, Compton's Butterflies, Chemistry Butterflies*, photos by Julia Strand.

PAGES 160-165 Collection of the artist.

PAGES 166-169 Photos by Scott McCue Photography.